DEAL

THROUGH TIME
Robert Turcan

AMBERLEY PUBLISHING

DEAL'S MOTTO
Ajuvate Advenas – Befriend the Stranger

For Wally and Daph Elvy – friends indeed – with love

First published 2012

Amberley Publishing
The Hill, Stroud
Gloucestershire, GL5 4EP

www.amberley-books.com

Copyright © Robert Turcan, 2012

The right of Robert Turcan to be identified as the
Author of this work has been asserted in accordance
with the Copyrights, Designs and Patents Act 1988.

ISBN 978 1 4456 0738 2

British Library Cataloguing in Publication Data.
A catalogue record for this book is available from
the British Library.

Typeset in 9.5pt on 12pt Celeste.
Typesetting by Amberley Publishing.
Printed in the UK.

Introduction

Deal is a hidden gem of an historic town on the eastern coast of Kent facing France. Its closeness to the Continent has largely shaped its history and fortunes. Julius Caesar successfully landed his invasion force on the flat pebble beach nearby at Walmer over two thousand years ago, thereby changing the course of our civilisation and arguably the western world also. The original harbour that he established further north at Richborough eventually silted up and by early medieval times Sandwich had become the pre-eminent port. A similar fate affected this harbour, in turn, as shifting soils were also later deposited here by tidal currents.

By Tudor times Henry VIII's independent foreign policy had created national enemies on the Continent. To combat threats to invasion he directed the construction of a series of three forts at Sandown, Deal and Walmer. Two of these survive in excellent condition and are cared for by English Heritage. An even more serious concern about attack from France arose during Napoleonic period when Deal became a hive of naval activity. A Naval Yard was established to repair and supply warships. Also elegant barracks were constructed to house marines and other military personal. Later, part of these quarters became the base for a task force designed to suppress the prevalent smuggling trade. Hostelries sprang up to accommodate visiting marine commanders and government officials. These later became the first hotels to serve holidaymakers who, following the pioneering example of Margate, could perceive the growing value of this business in later Victorian times. As always the arrival of railway communication vastly boosted the town's economy. However, in Deal's case it was piecemeal and not fully functional until the relatively late date of 1881.

Around a century ago Deal was an admixture of fishing industry, naval and military garrisons and seaside resort. The present pier is the only surviving pleasure one in Kent and replaces two earlier ones. Of course a promenade structure extending into the ocean was a necessary amenity for any Edwardian seaside town with leisure pretensions. Many postcard images survive depicting crowded scenes around Deal's pier of people either listening to musical concerts, sport angling or simply enjoying the sea air.

Apart from dockyard workshops the only heavy industry in the vicinity was east Kent Coalfield with its nearest mine at Betteshanger. This brought an influx of miners from more depressed regions, but has now closed along with the overall near demise of this source of national energy. Today, Deal is a magnificent example of sensitive preservation of its architectural heritage. There are its leading buildings such as its Castle and barracks which partly due to the robustness of construction and ownership are as good as new. Lesser places such as the Town Hall, theatre and churches are soundly maintained. However, the sheer delight of its pretty terraced streets owes much to the love of its residents. They enjoy an enviable environment which has been a magnet for artists, actors and writers seeking the quiet pleasures of this cultural oasis. Through time Deal seems only to have improved and few towns, even in the blessed county of Kent, with the exception of Faversham can claim this epitaph. Hopefully the beneficial changes observed from these images will encourage the uninitiated to discover these towns' undeniable charms.

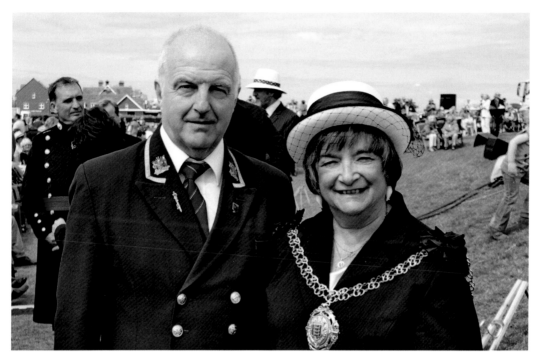

Above, Deal's Mayor Councillor
Marlene Burnham and her attendant
Barry Finch. To the left, fishermen
prepare their boats while flowers
blossom.

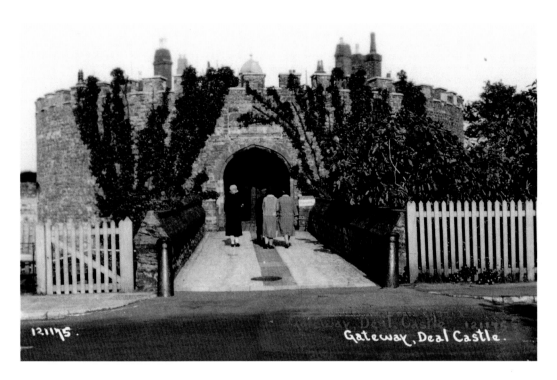

121175. Gateway, Deal Castle.

Deal Castle

Built as the largest and central of three forts along this stretch of the coastline nearest France, it was designed to protect England from attack at the time of Henry VIII's very independent foreign policy. The design outlining the shape of the Tudor rose is formed by concentric circles which helped deflect artillery missiles.

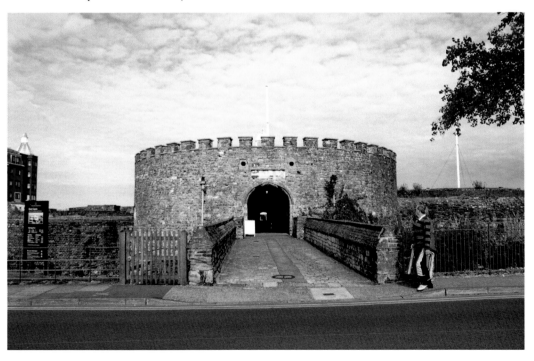

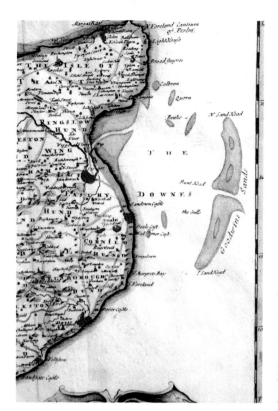

Old Deal Maps I

The map above by Morden dated 1695 was the first to show the roads of Kent in detail. It also illustrates Deal's strategic naval importance opposite the Downs. This deep water channel of sea between the coast and the treacherous Goodwin Sands acted as an anchorage for hundreds of ships following the silting up of Richborough and Sandwich harbours. Below, a map of the late eighteenth century shows the division between the earlier established Upper Deal and Deal with its grid pattern of streets.

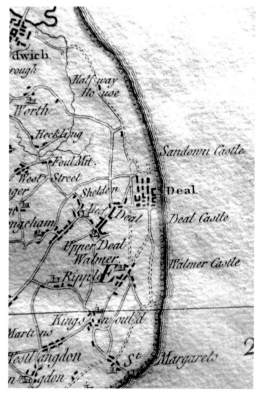

DEAL

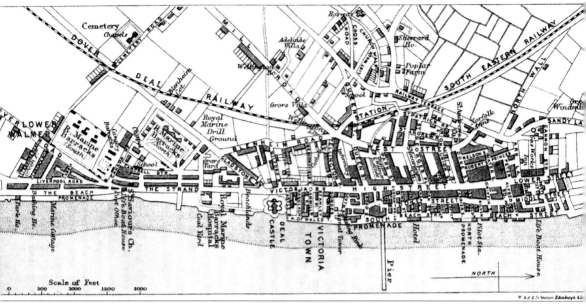

Old Deal Maps II

The detailed large scale map of Deal above was drawn in mid-Victorian times. It illustrates urban growth and the additional amenities of a railway connection and pier. Below, the sites of the three castles, Sandown, Deal and Walmer, identifiable along with the three former lifeboat stations which are currently amalgamated into the one at Walmer.

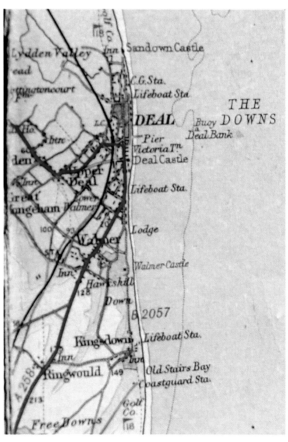

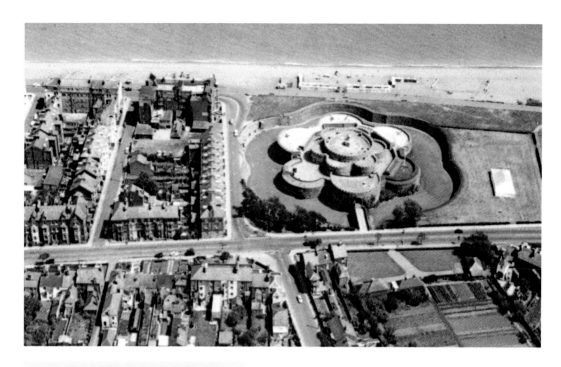

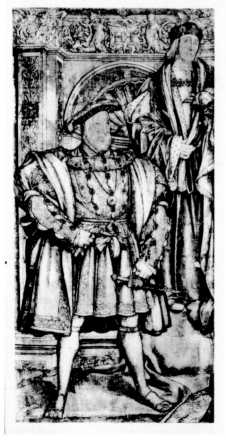

Henry VIII's Dynastic Obsession and Deal I

This handsome image of Henry VIII was painted by Hans Holbein on instructions from Thomas Cromwell who was eager to portray his monarch as a desirable bachelor despite his early signs of physical decline and unenviable record of three previous wives. Although a first marriage ended in divorce and subsequent ones in beheading and death from natural causes, Anne of Cleaves was persuaded into a liaison. Both parties to this contract of marriage were deceived or fooled by Hans Holbein's portraits as Henry was disappointed by the disparity in artistic licence and harsh reality after he met his bride to be following her arrival and stay at Deal Castle. (Courtesy of Elizabeth Norton)

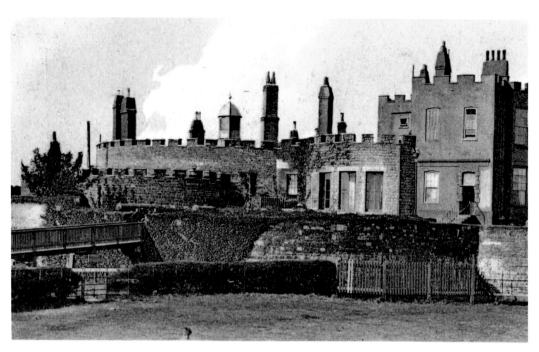

Henry VIII's Dynastic Obsession and Deal II

There are few more axiomatic themes in British history than Henry VIII's obsession with producing a male heir to succeed to his throne. When Anne of Cleaves first met the anxious Henry at West Kent the plain daughter of a German Duke did not please his highness. Although a marriage did take place it soon ended in divorce and Anne was paid off and settled at Hever Castle, as returning home would have caused embarrassment to her family. Her first night in England, whilst staying at Deal Castle, started badly when she complained that the accommodation was not suitable. She was, however, subsequently mollified by an excellent meal! (Courtesy of Stephen Porter)

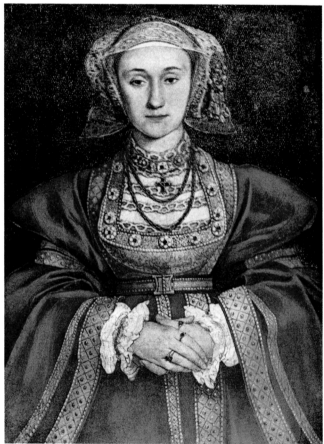

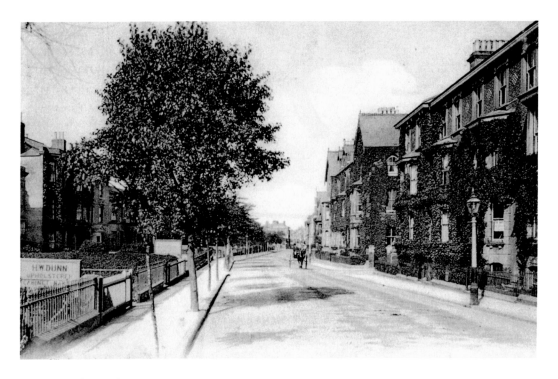

Victoria Road

Victoria Road is an imposing entrance to Deal from the south. After passing the castle on the right motorists are soon into this street of substantial three-storey houses of the late Victorian era. The old image above with an empty street, apart from an advancing pony and trap, shows the buildings covered in creeper, which was a highly fashionable practice, but has since been largely abandoned to aid maintenance.

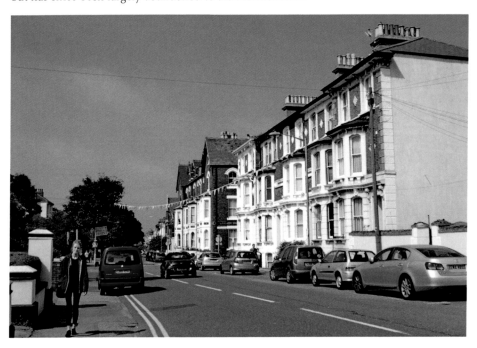

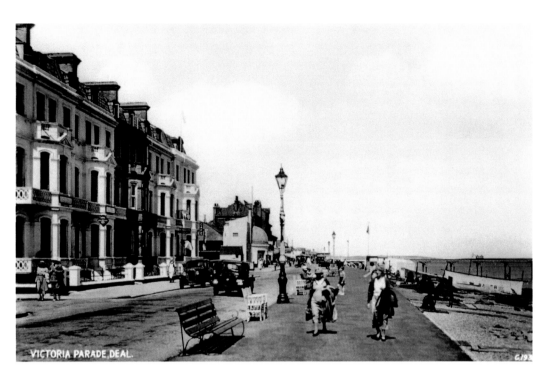

Victoria Parade Deal

Victoria Parade was built on the site of the naval yard. Prince of Wales Terrace was erected in 1860s and reflects the confident solidity of architectural style at this time of expanding empire and British world leadership. The sepia shot taken in the 1930s shows vehicles of that period, but fortuitously this recent snapshot also includes a vehicle of similar vintage.

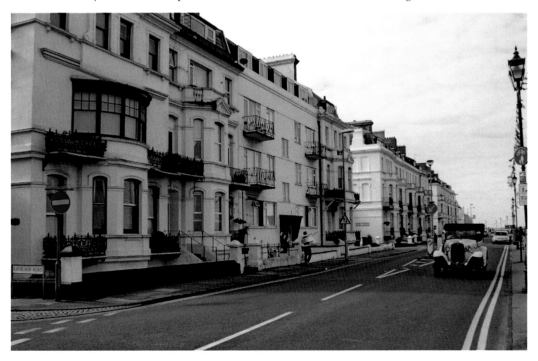

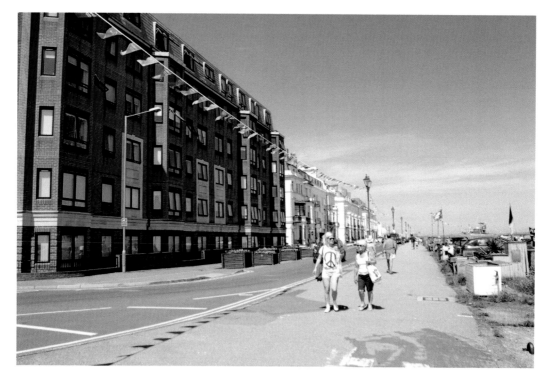

Queens Hotel

The railway was relatively late coming to Deal from Dover in 1881. By 1886 its proprietor, the London, Chatham & Dover Company, planned to build a luxury hotel to cater for the growing number of holidaymakers. Originally called the South Eastern Terminus Hotel, it later became known as the Queens. Closing in 1977 it was sadly destroyed by a fire in 1981, which burned for forty hours. Now the site is occupied by the modern flats seen above.

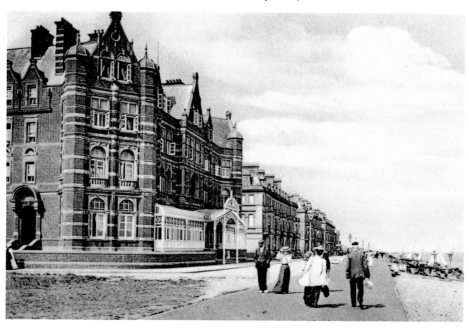

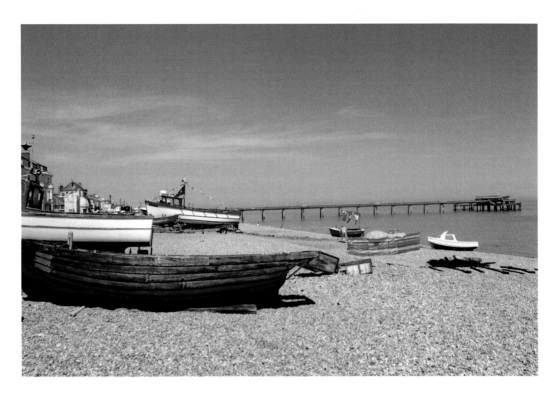

Iconic Images of Deal

Without a harbour Deal boatmen were in demand to operate tenders serving larger vessels anchored offshore requiring stores and taxi rides for crew. Gradually this trade declined as the importance of the Downs was reduced from its Napoleonic peak. Fishermen, however, have always beached their boats on the steeply sided drifts of shingle and pebbles and it is this relaxed image which personifies Deal's quintessentially maritime nature in the minds of its devotees.

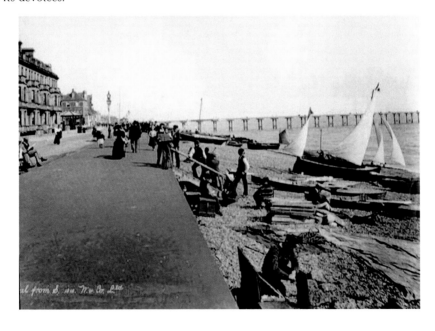

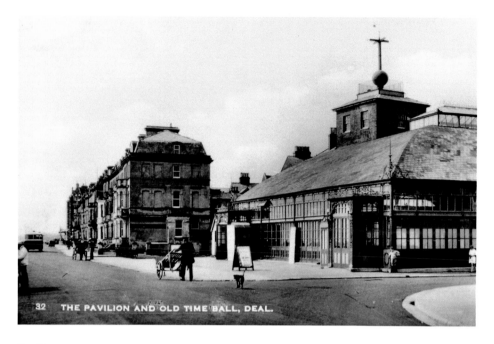

32 THE PAVILION AND OLD TIME BALL, DEAL.

Pavilion

In the sepia picture above, the pavilion occupies this corner site on the seafront. Once all this area was covered by the naval stores supply yard and the residence of the official in charge. The artist's impression below, including Lloyd's, shows the vicinity redolent of the age of sailing ships and furtive smuggling gangs.

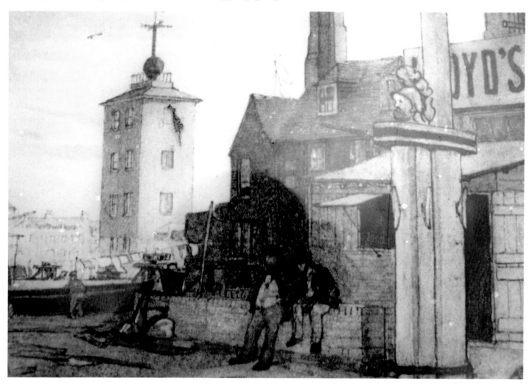

The Ball Tower

The Ball Tower was built on the old signal station site to provide ships chronometers with an accurate, to the second, time check relayed from Greenwich at 1 p.m. every day. Operating from 1855 to 1927, it became obsolete with the introduction of the BBC radio time broadcasts. Today a maritime museum is housed within its walls and each hour the falling ball mechanism reminds us of its former use.

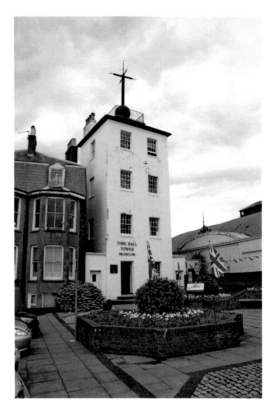

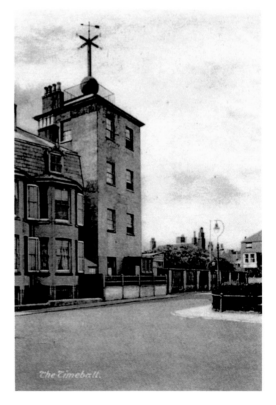

The Timeball.

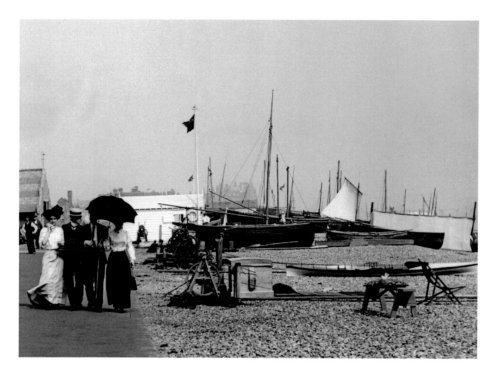

Edwardian Holidaymakers

These pictures, taken to provide tourists with images for the craze of sending postcards to each other, both to impart terse messages and form large collections, which are still sought by collectors and local historians alike, give an excellent insight into the genteel leisure activities once available at Deal. A formally dressed and universally hat wearing concert audience fills every available seat below while a less populous scene above shows two holiday couples promenading along the front.

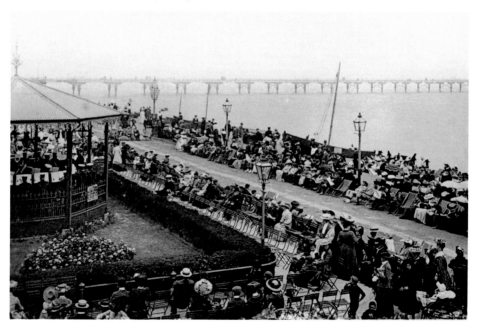

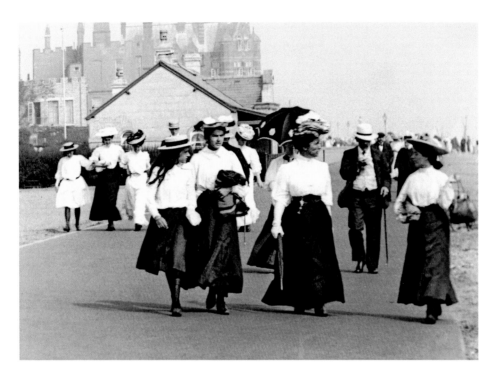

Pedestrians Then and Now

Costumes from the Edwardian area are illustrated here. Long ankle length full skirts were then *de rigueur* with tailored white blouses and straw boaters for ladies. Meanwhile gentlemen were considered badly attired without a fitted waistcoat and walking cane. Much more relaxed clothing trends prevail today where more or less anything goes so long as it does not break the laws of decency.

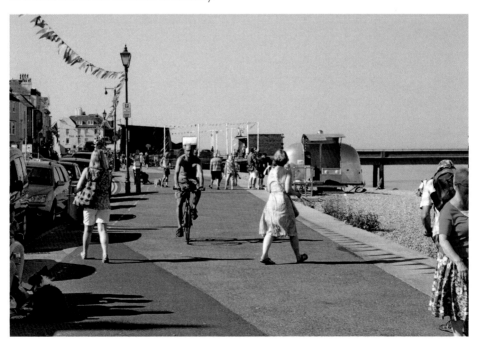

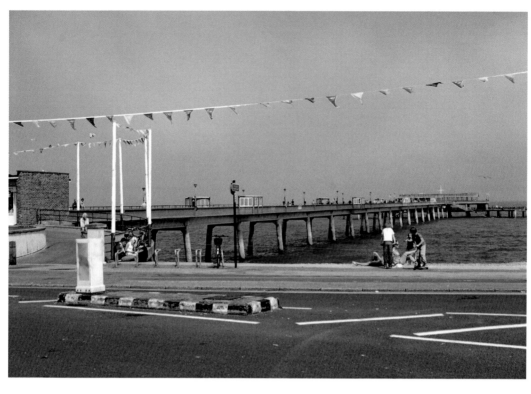

Deal Pier I

Deal's modern pier replaces one lost due to a shipping accident in 1940. It fulfils the same basic function as a walkway and platform for sea anglers.

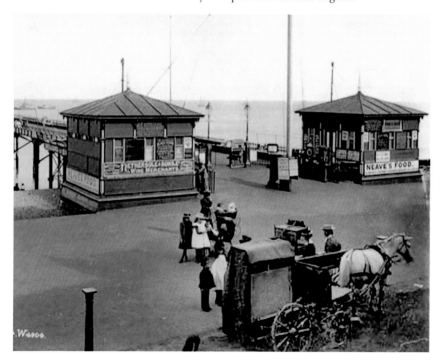

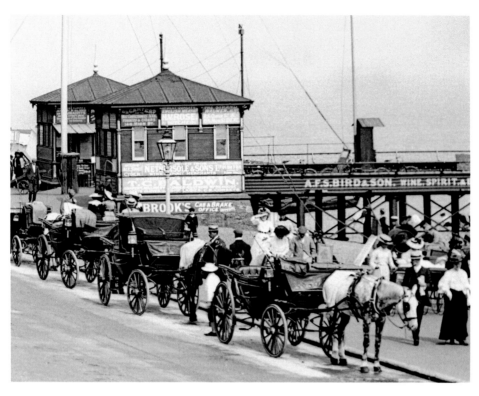

Deal Pier II
Above, a rank of horse-drawn taxis await potential customers by the pier. Whereas below, a contemporary photograph portrays the official in charge of fishing fees enjoying a restful moment while trade is slack.

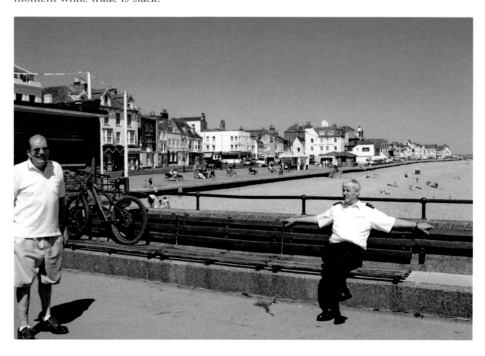

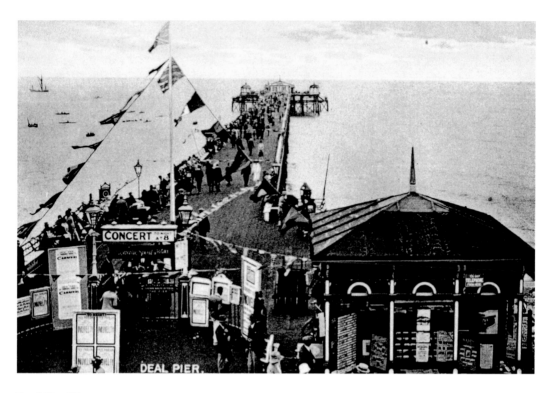

Deal Pier III
The modern structure of Deal Pier is steel encased in concrete. It is a simpler, yet more striking, design than its cast iron predecessor with a café at its seaward extremity. The entrance today is through a more restricted area than the old style one with its two square pavilions.

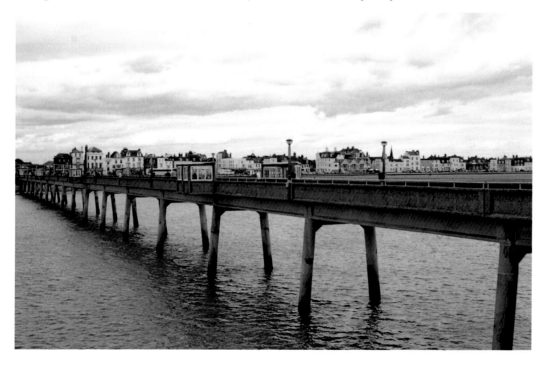

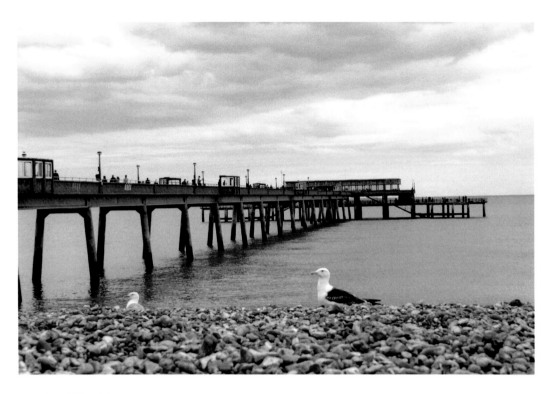

Deal Pier IV

Deal Pier is frequented by sea anglers and their attendant scavengers – seagulls – who hover around ever watchful for scraps of bait or other morsels which they volubly argue over amongst themselves. The old function of a landing stage has become redundant as paddle steamers no longer ply their trade around the Thames Estuary and Kent coast.

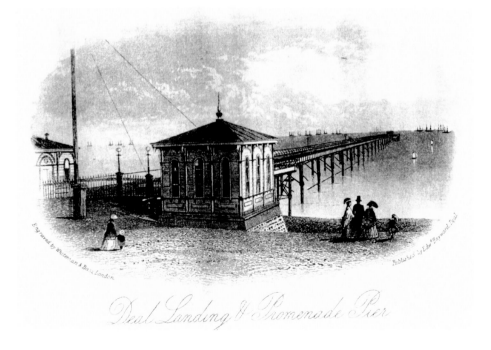

Deal Landing & Promenade Pier

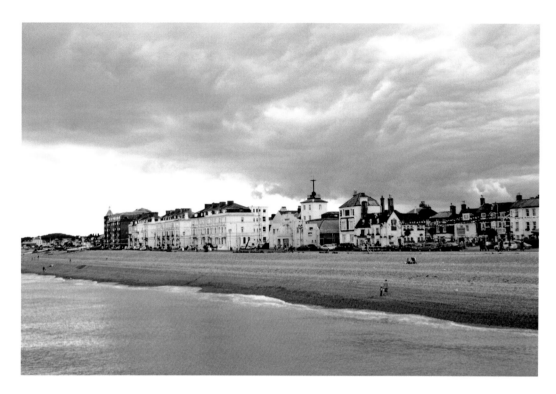

Deal Beach Looking Southwards I

A dramatic storm cloud looms over the view southwards of Deal beach in the landscape photograph above. It serves to highlight the mainly white painted, smart buildings which distinguish this historic town. When the postcard of the same area was produced in the 1920s, lines of empty deckchairs optimistically awaited an influx of sunbathers.

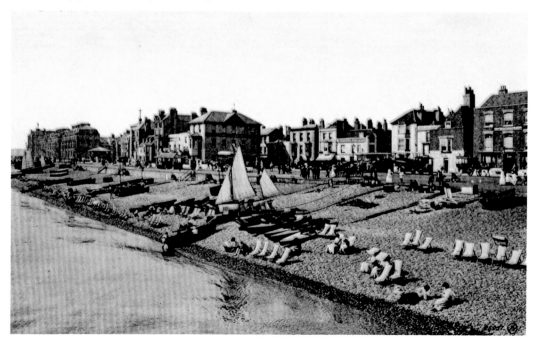

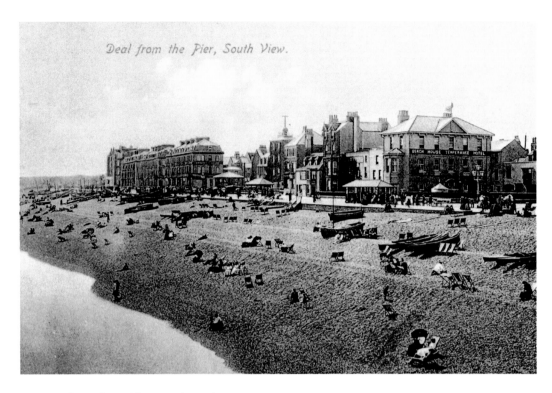

Deal from the Pier, South View.

Deal Beach Looking Southwards II

Enlarged images from similar angles to those on the opposite page reveal that despite a cloudless azure sky and calm warm waters the beach is now much less populous than in the past. However, the graceful lines of seafront buildings keep their well proportioned splendour.

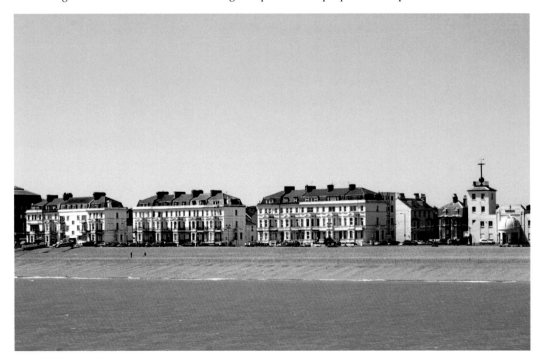

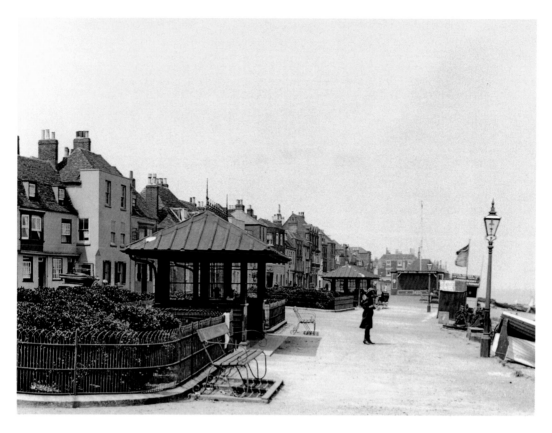

Central Parade

These seafront photographs provide atmospheric images of a lost age when travel by either road or sea was slower and there was less evidence of commercial activity and marketing slogans.

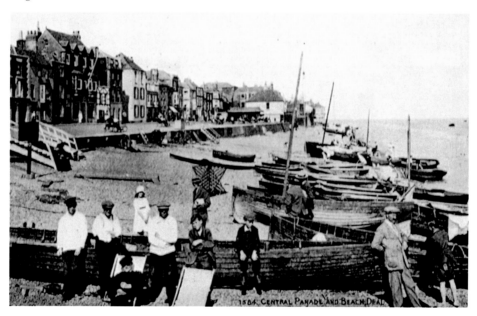

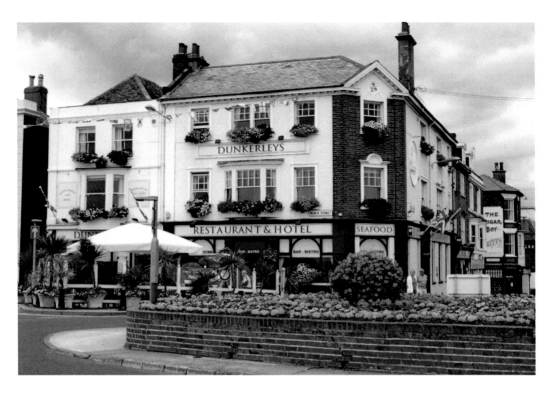

Dunkerleys and the Kings Head

The Kings Head and Dunkerleys stand at a pivotal point facing the beach. They are popular places for refreshment and due to the abundance of bright floral decoration an outstanding feature of Deal. The landlord admired window boxes on buildings in Austria and has very successfully emulated this jolly custom.

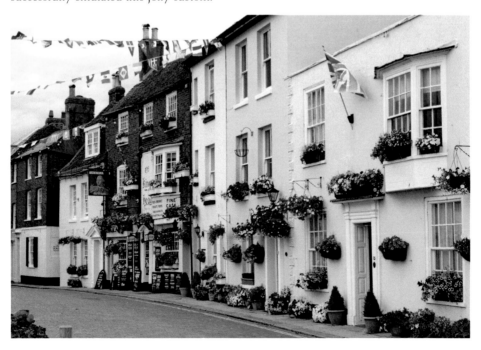

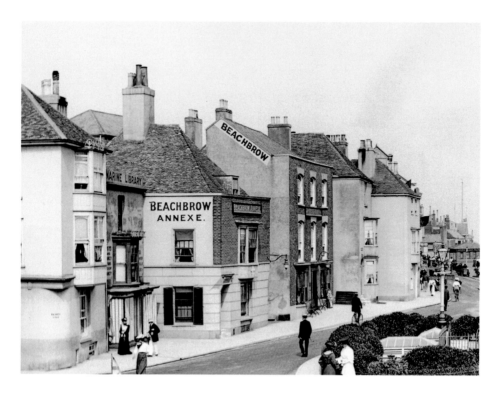

Beachbrow Hotel

At the heart of Deal on the promenade looking out to sea stands the Beachbrow Hotel. The hotel was established in the late eighteenth century and was used by Nelson's officers to stay in while their ships were anchored offshore. Some of the main rooms have excellent views out to sea and a clear vision of France on fine days, while below ground its old dungeons still survive.

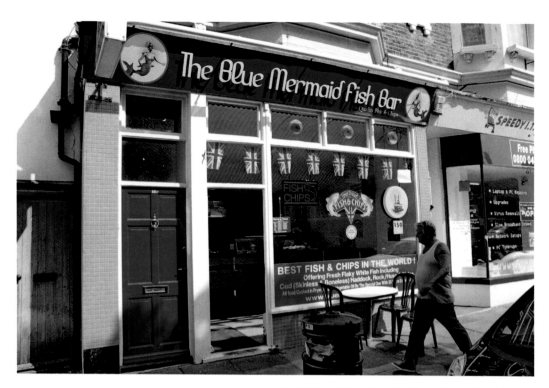

Gone Fishing

Furnishing the entrance to Deal's third pier on this spot is the arresting statue *Embracing the Sea* by sculptor John Ruck. This 300 cm bronze figure of was erected in 1998 and perfectly encapsulates the angling soul of the town. Tucked away in the back streets the Blue Mermaid Fish Bar is renowned for the excellence of its British staple – fish and chips.

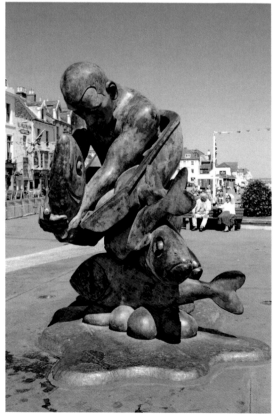

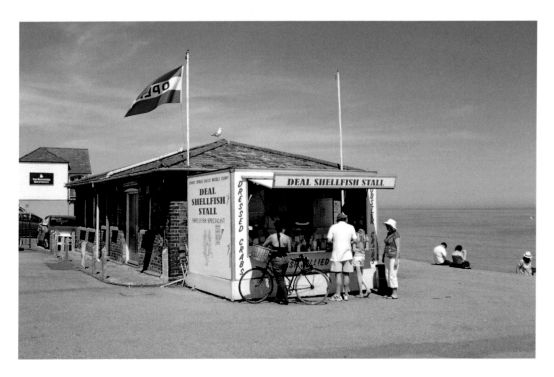

She Sells Shellfish on the Seashore

Conveniently close to the beach stands this popular stall providing tasty snacks of all manner of crustaceans. Hungry bathers provide a steady stream of custom as shown in these photographs capturing the relaxed holiday mood to be found on a radiant summer's day in July.

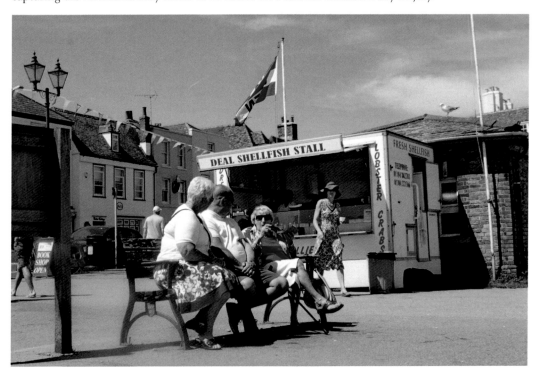

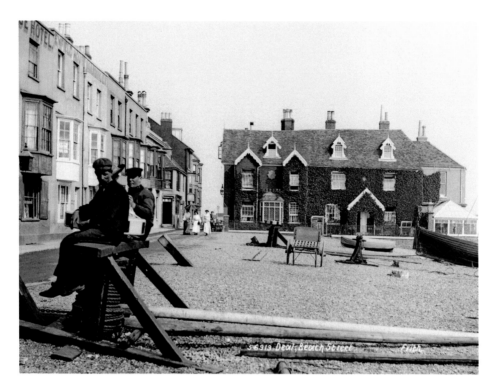

Deal Boatmen

For centuries Deal boatmen have been revered for their skill and bravery at sea. When not fishing, crewing their boats or waiting for the tide or weather, what better pursuit that unites all sailors is there than gathering together in the sun to idly chat and share the bond of friendship?

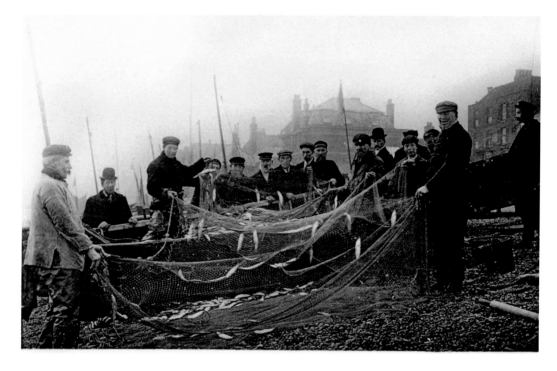

Herring and Sprat Fisherman of Yesteryear

These scenes of trawler men gathering their catches of herrings and sprats on Deal's beach are relics from the past. Common market rules, different mechanised techniques of fishing and changing consumer tastes have meant that this way of life has faded into history. At the turn of the century, however, it was an iconic image of Deal to be portrayed on tourist postcards.

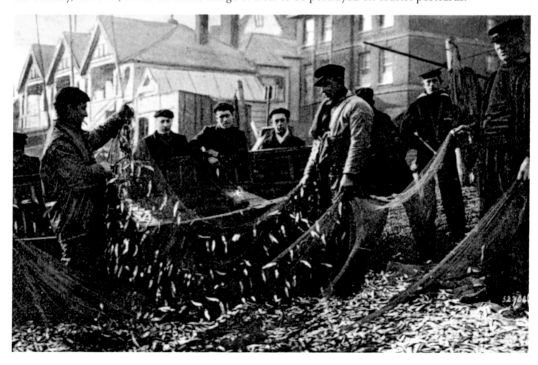

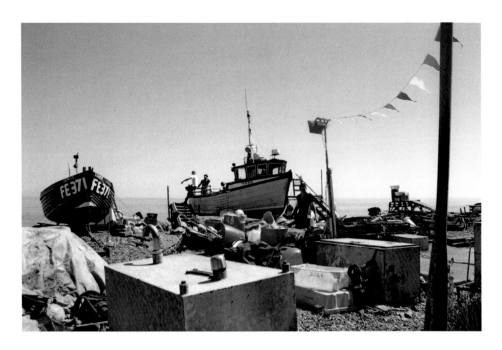

Boatmen and their Paraphernalia

Traditionally clinker built boats have been used by Deal boatmen. They require much maintenance and care to remain seaworthy. In the past large sections of the beach front were used for repairs and other stores and equipment, but today it is confined to a section by Prince of Wales Terrace. Fondly remembered by older readers, deckchairs also seem to have faded from widespread general usage.

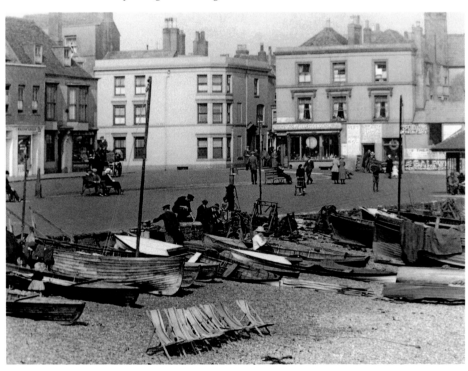

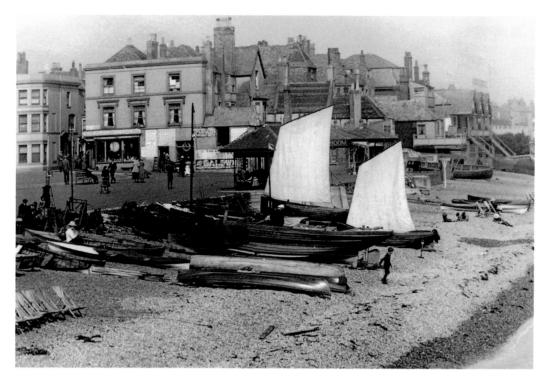

A Working Beach Becomes a Pleasure Beach
Where gaff rigged working boats parked amongst a beach strewn with flotsam and jetsam, bathers now relax on immaculately clean pebbles close to relatively clean pollution-free seawater.

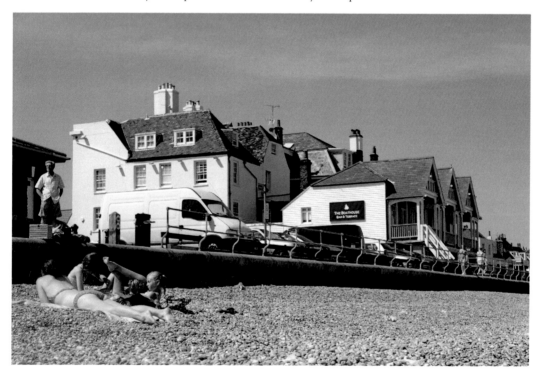

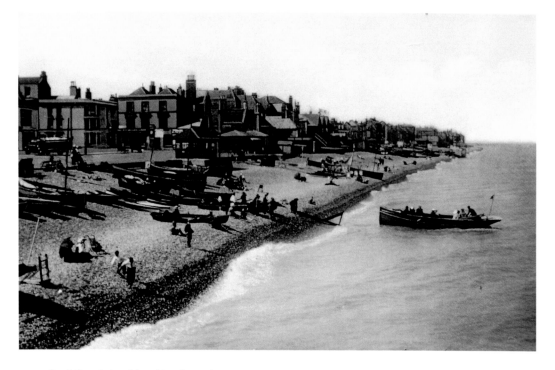

Deal Beach Looking Northwards

This handsome vista of pastel washed cottages and houses cutting the skyline in front of a wide shingle beach used almost entirely for fishing, walking or bathing are the present quintessential character of this hidden gem of a town. In pastimes the seashore was a working area frequented by fishermen and other boatmen whose livelihoods relied upon a variety of marine activities.

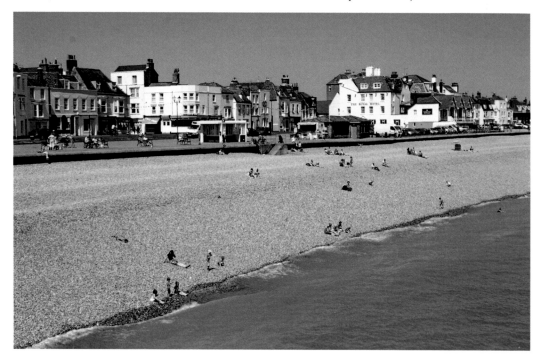

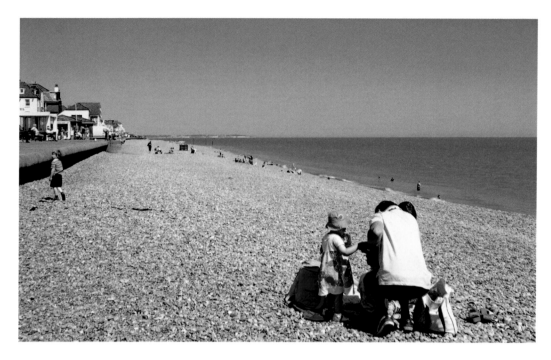

Deal Beach Looking North
Some of the rusty old boat winches used for hauling craft on land survive at the southern end of the promenade where the few remaining fishing boats are kept. However, in the old photograph they featured along a much longer stretch of the beach. Clothes fashions have constantly changed, but mothers are still careful to cover their infant's heads with precautionary sun hats.

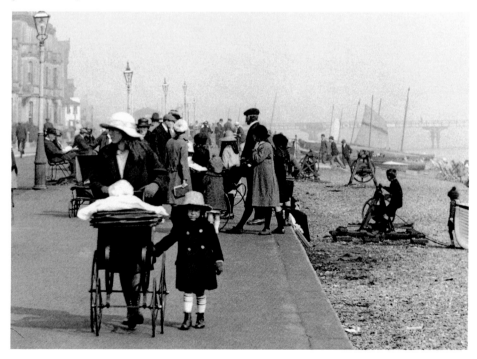

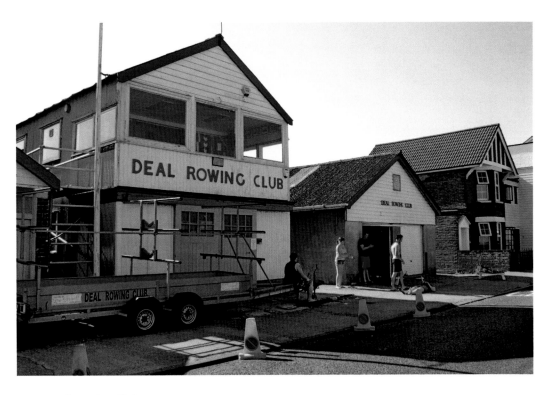

Deal Rowing Club

Deal Rowing Club has been established on the seafront since 1927. It is a friendly club welcoming all ages and standard of rowers. They organise many social and sporting events throughout the year as well as providing gym and other training facilities.

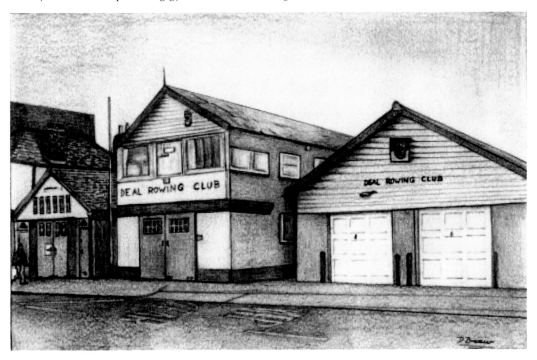

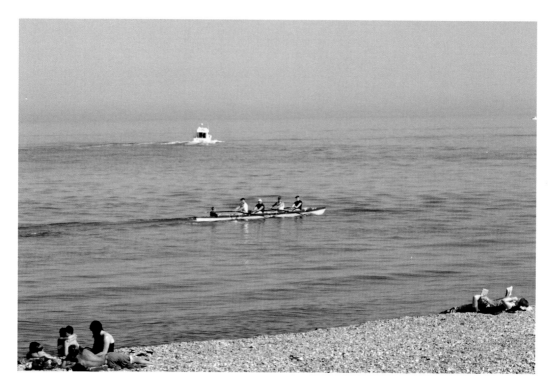

Fine Boating Weather

These seascape photographs serve to illustrate Deal's main recreational asset. On a tranquil summer's day rowers, yachtsmen and power boats take to the sea to enjoy their pastime in perfect conditions.

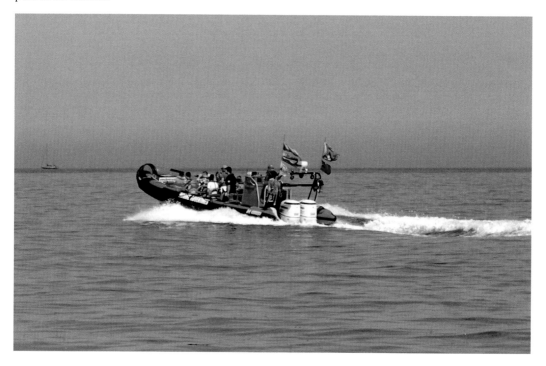

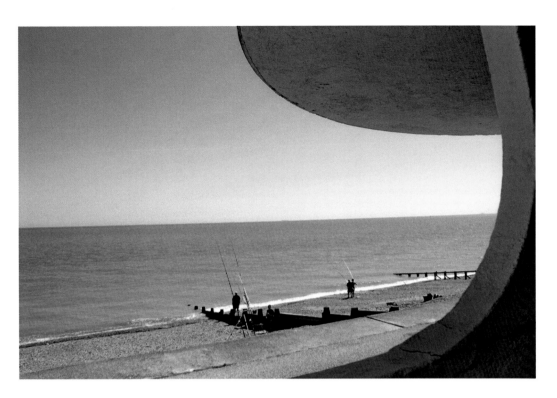

Sea Angling

Deal with its long pier and steeply shelving shoreline is a Mecca for sea anglers. Pleasure Angling caters for these enthusiasts with supplies of tackle and bait. Above, a peaceful scene of fishermen is framed by a concrete seafront shelter.

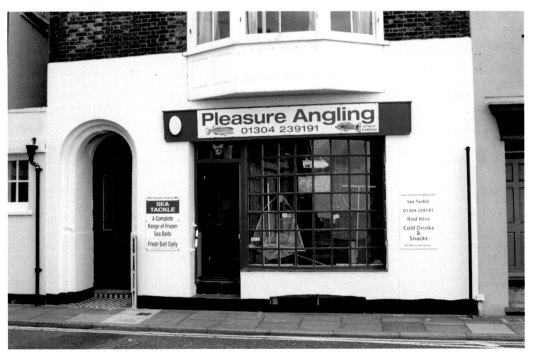

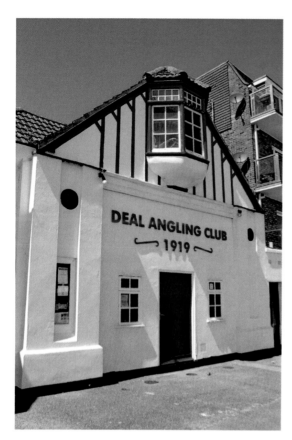

Deal Angling Club
Deal Angling Club, founded in 1919, is currently a thriving organisation. The war in 1939 caused a cessation of activities until 1946 when these resumed with club funds totalling less than four shillings (20p)! Over nine hundred senior and junior members are able to test their skills in over sixty competitions a year. However, the couple below seem to have a more relaxed approach, enjoying the sunshine by the lazy waves.

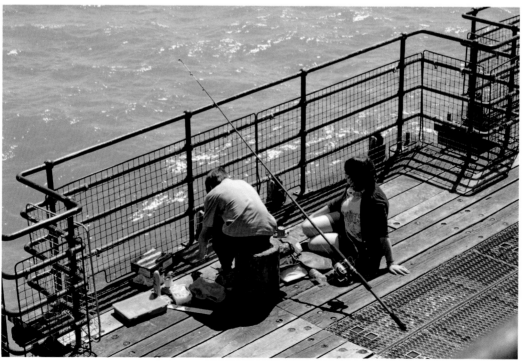

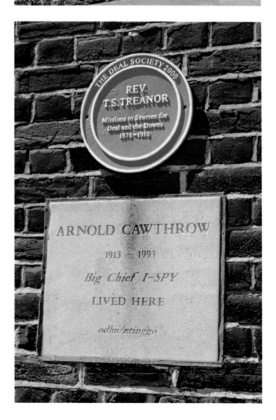

Mission to Seamen

An unusual house on the esplanade with lancet windows and a Deal Society blue plaque was the base for Mission to Seamen from 1878–1910. Later it was the home of Arnold Cawthrow, who took over from Charles Warrell as Big Chief of the *I-Spy* children's book series. The latter was a former headmaster who devised these books to occupy and amuse children in a quasi-educational fashion.

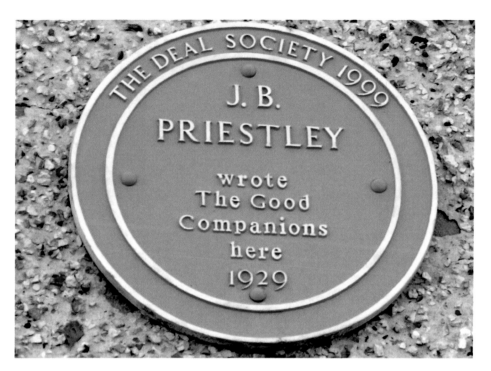

J. B. Priestley and Deal

J. B. Priestley wrote the novel *Good Companions* while residing at Deal. This work was his first major success and in 1929 earned him the James Black Memorial Prize for Fiction. Not universally admired by literary critics of the time, the story about the trials and tribulations of a travelling concert party in the inter war years was commercially popular. Its picaresque style, characters and setting have less modern relevance, however. Deal Society has rightly honoured his memory with a blue plaque on his former coastal home.

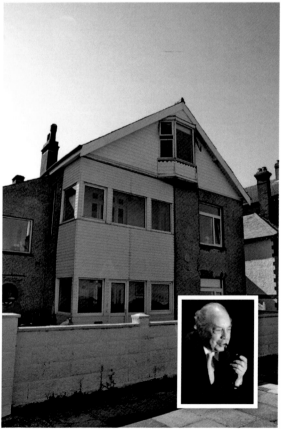

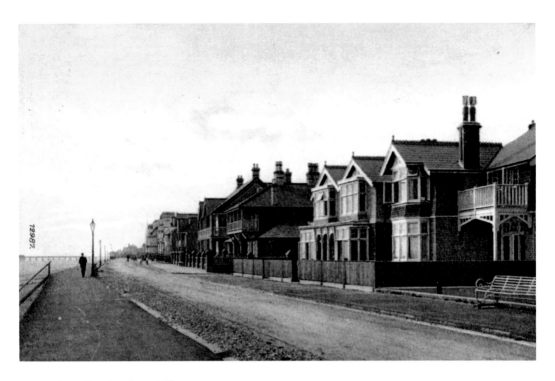

Edwardian Seafront Villas

The street scenes here reveal few changes over a century of time. Parked cars are the greatest alteration with more widespread use of white paint, but a switch from gas to electric street lights is a more subtle development.

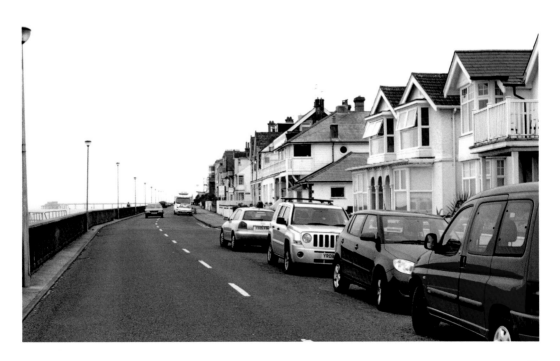

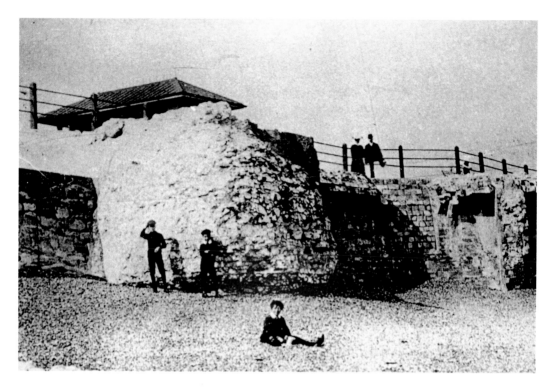

Sandown Castle

Little remains of Sandown Castle as it has been partially destroyed by the sea. Once it would have been identical to Walmer Castle and was the northern fort of three established by Henry VIII to defend the important shipping lane of the Downs against foreign invaders.

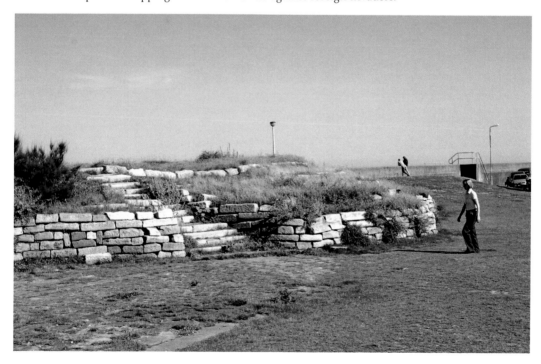

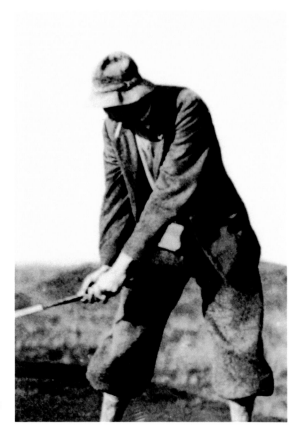

Royal Cinque Ports Golf Club
Established in 1892, the Royal Cinque
Ports Golf Club has an imposing
clubhouse once frequented by George V.
The fabulous course has been the
setting for many championship
competitions. Above is an old timer
about to hit a hole in one, resplendent
in his tweed plus fours, hat and cigarette
firmly clasped between his lips!

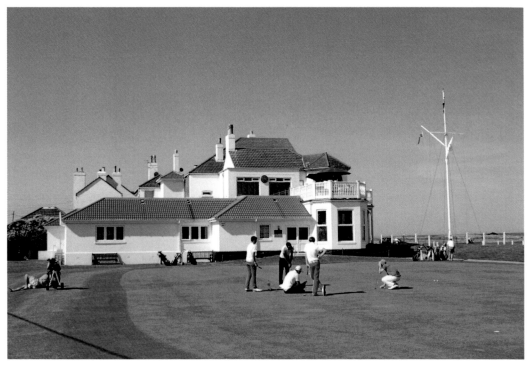

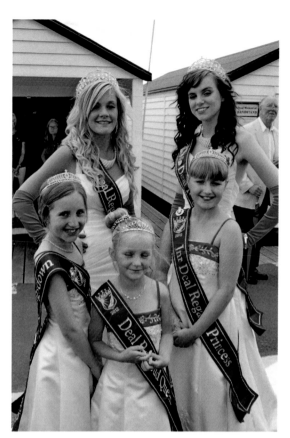

Beautiful Deal
Deal beauty queens and princesses were snapped here while on duty at a concert by the Royal Marines. Whereas a less posed shot of more cosmopolitan ladies was taken in the town during festival time.

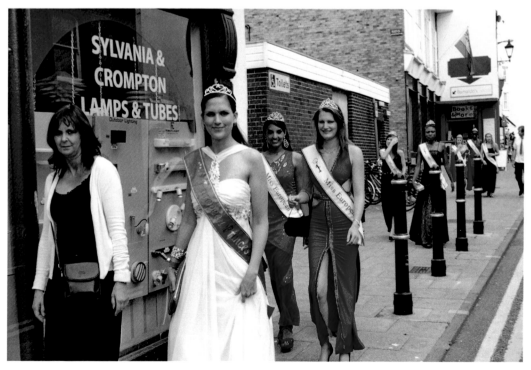

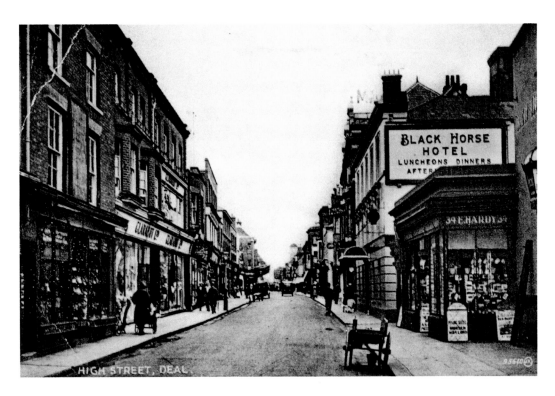

Deal High Street I

The old sepia picture of the inter war years shows Deal High Street with the occasional small delivery van or hand cart. Today, much of this area has access for pedestrians only and, as seen in the picture below, is enhanced by urban landscaping and municipal flower displays.

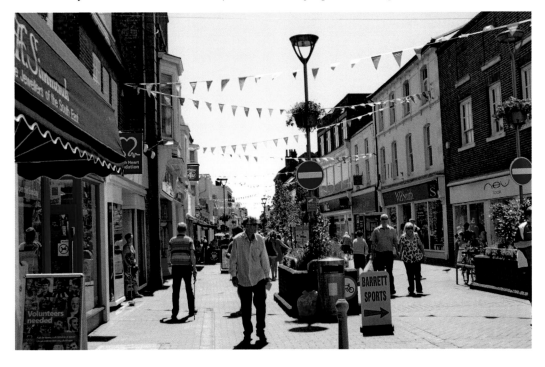

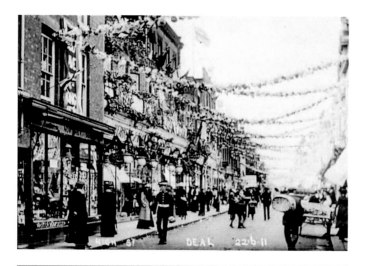

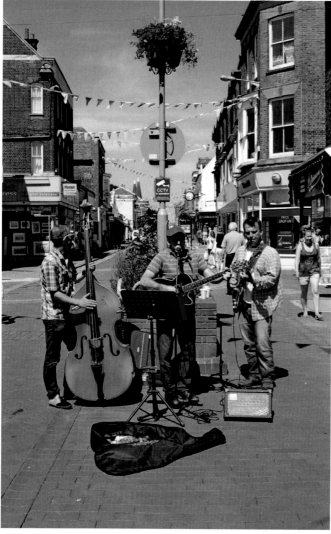

Deal High Street II
A festival air pervades these two pictures old and new. Bunting festoons the buildings in 1911 to celebrate the coronation of King George V. In July 2012 a very competent pop group entertains shoppers during the town's annual festival.

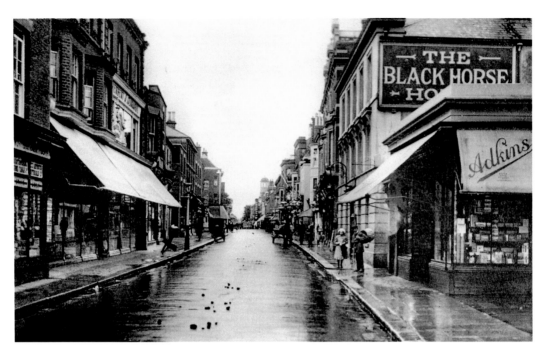

Deal High Street III

These pictures of Deal High Street display contrasts in weather and mood. The old picture has a somewhat miserable atmosphere of a virtually empty street littered with horse droppings whilst the latter has a happy, sunlit, bustling holiday feel.

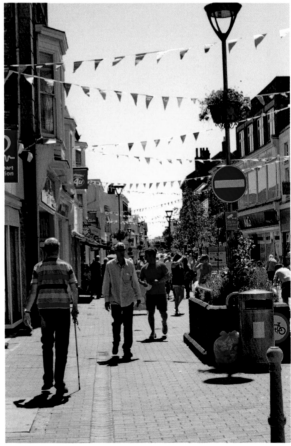

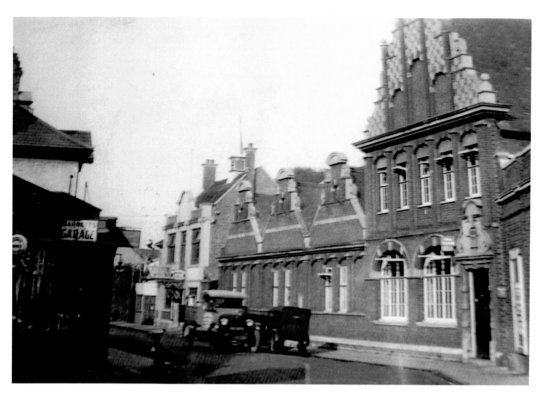

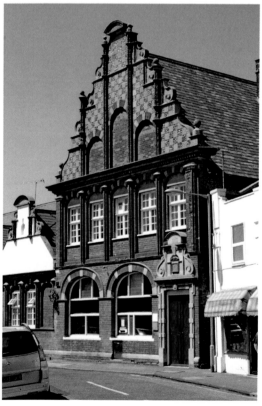

Deal Post Office Buildings
Save for the vintage vehicles there is little difference in the old and new pictures of Deal post office buildings. They do, however, illustrate a strikingly unique style of Edwardian architecture. Despite much detailed ornamentation the overall effect of repeat motifs produces a uniformly pleasing overall effect.

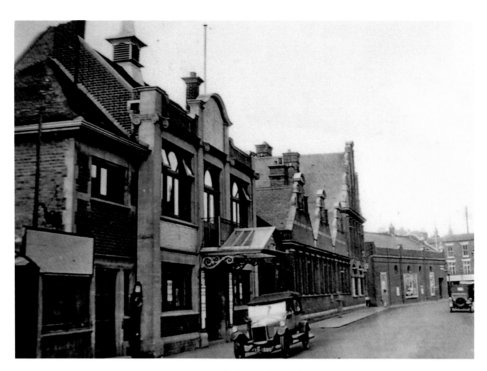

Astor Community Theatre I
An exciting discovery in Stanhope Road was the Astor Community Theatre where I was warmly welcomed by its artistic director James Tillitt. This Edwardian playhouse was rescued in 2009 and now provides multipurpose arts facilities for music performances, film, live theatre, exhibitions and other social events.

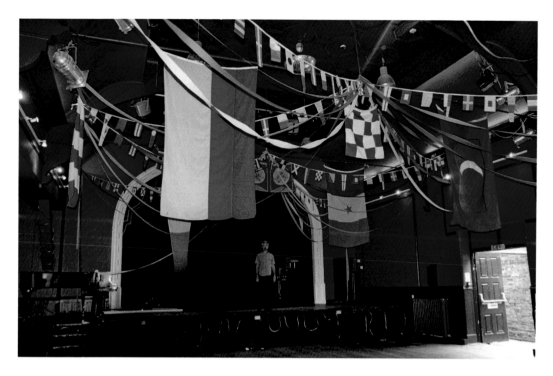

Astor Community Theatre II

A diverse programme of planned 2012 events at the Astor Community Theatre provides something to suit virtually everyone's tastes. In May alone a story from Charles Dickens was portrayed, there was a bedroom farce, nostalgic music, cabaret singers and vintage films.

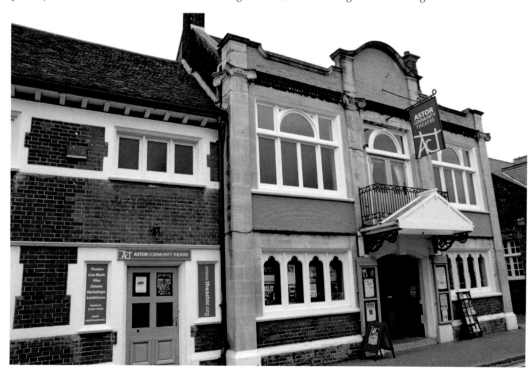

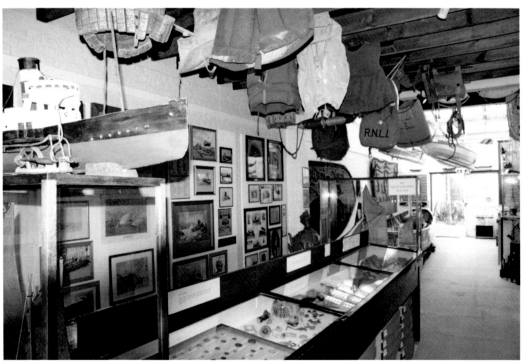

Deal Maritime Museum I

Known as the best kept secret in Deal is its Maritime Museum, hidden in the heart of the town near the High Street. Given by a generous benefactor the site has a history of varied use. Once this was an area for market gardeners producing food for the fleet nearby and later it was developed into workshops where ladders for the hop fields and velocipedes were manufactured. Volunteer Ken Whaymand is pictured outside the entrance wherein old lifejackets, lifeboat models and portraits of past Deal mariners are amongst the many exhibits.

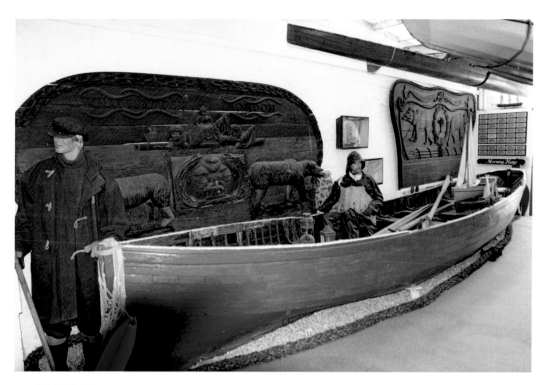

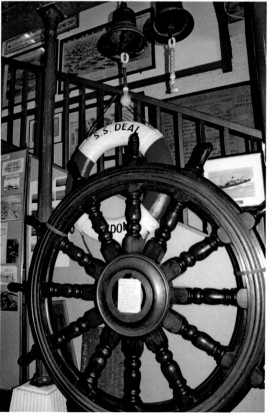

Deal Maritime Museum II

Above is a picture of the only two known carved spar boards from owner of the *Cutty Sark*, 'White Hat' Willis's ships, who lived at Deal. Other exhibits include ships' wheels, bells and memorabilia from the town's previous Royal Marine garrison. Too many other exhibits are to be discovered here to be included in this caption, but a visit is strongly recommended.

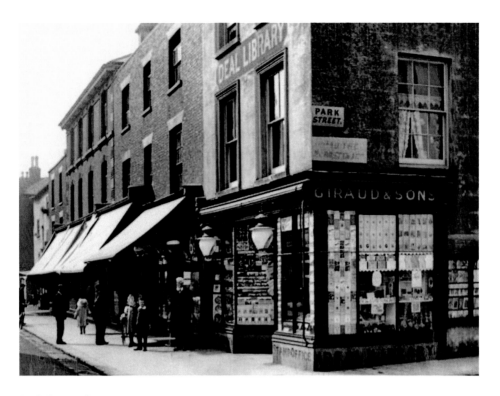

Park Street Corner

This corner of Park Street and the High Street was much photographed in former times. It once housed a library and shops with sun awnings to protect window shoppers from inclement weather and the goods displayed from the destructive effect of sun rays. Recently a Sue Ryder charity shop is preparing to open while the awnings have disappeared.

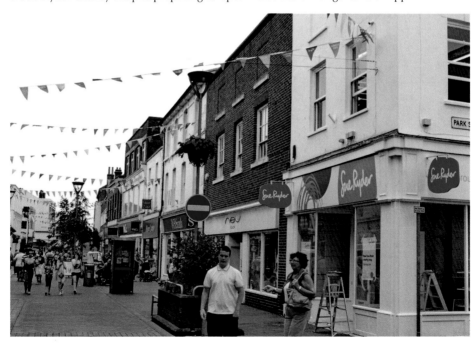

The Boy with No Shoes

Deal seems to either attract artists and writers because of its relaxed ambience or has inspired normal mortals by its beauty into becoming them. One such modern writer is William Horwood, whose childhood experiences in this town are thinly disguised in his book called *The Boy with no Shoes*. There is a local legend that as a child he was rescued from the sea, whilst in difficulty, by Bubbles Fry (a local fisherman) who lived in the delightful cottage below in Capstan Terrace.

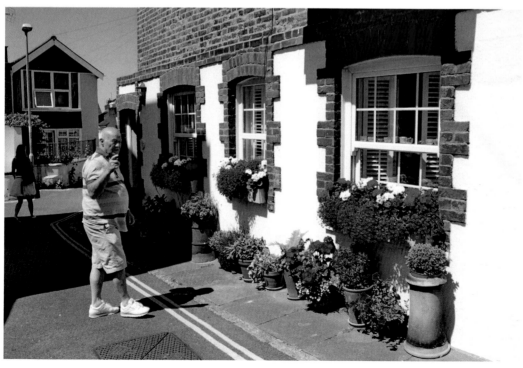

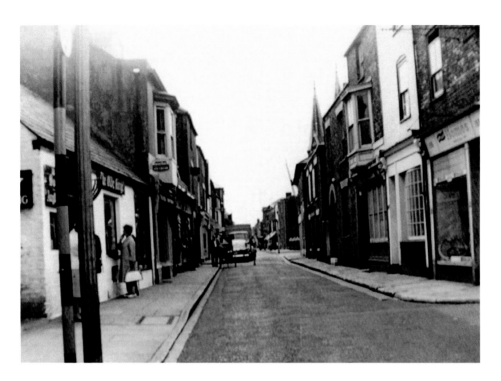

Deal Backstreets I

These old images of Deal's backstreets show what a quiet unchanging locality for fishermen's homes this was. The strength of protection from unsuitable development is underlined by the modern images of this designated conservation area seen opposite.

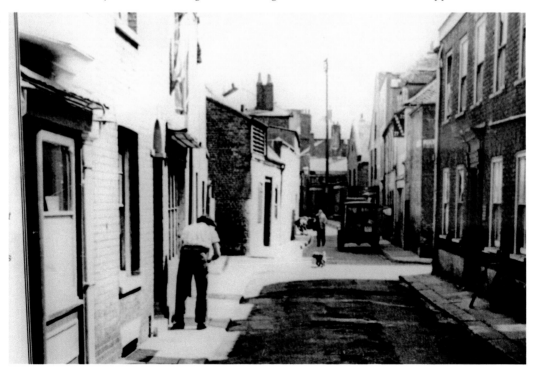

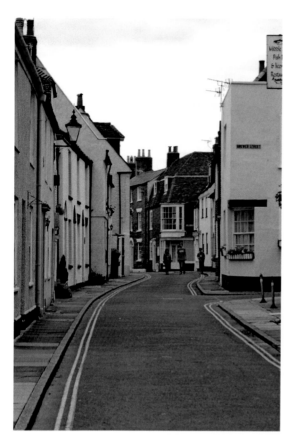

Deal Backstreets II
Uncongested alleys and streets with beautifully maintained artisan's terraces remain a lovely feature of Deal. They now to some extent house weekenders from London or retirees seeking a pleasant haven to spend their declining years. The subtle changes in the pastel hues of masonry mark different ownerships, but all residents unite to preserve this unique environment.

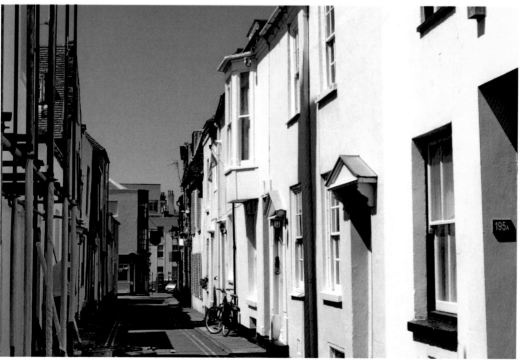

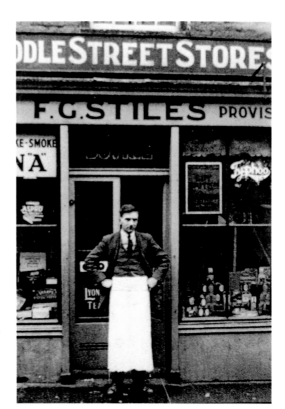

Deal Shops I
Once the small backstreet shops were mainly provision stores like the one featured here owned by F. G. Stiles. Today, however, the retail scene is typified by small specialist boutiques selling gifts, fashion clothes or antiques and bric-à-brac. These are liberally interspersed with inviting cafés.

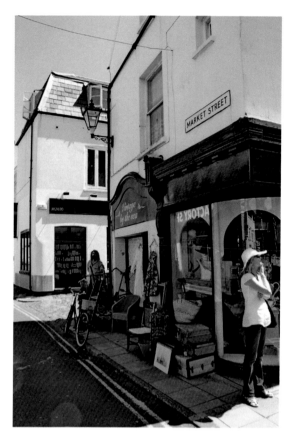

Deal Shops II
A. M. Jennings butcher's shop, pictured below, would no longer be allowed to display uncovered carcases of meat in its shop window. However, the present antique shop at the appropriately named Market Street is permitted to pile its wares onto the pavement for potential buyers to inspect.

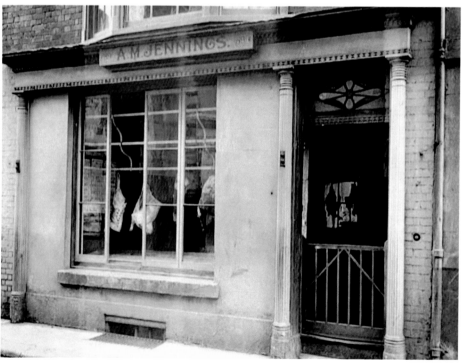

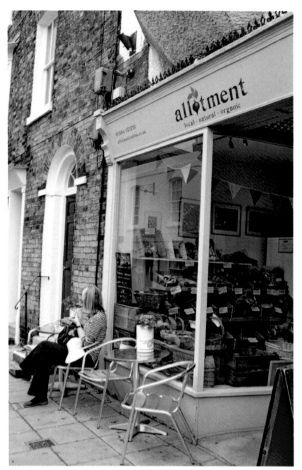

Deal Shops III
Goldfinch & Son's shopfront has the Dickensian appearance of the one from the Quality Street advertisement. No attempt at artistic window dressing took place and neither is this needed today at allotment where the freshness and quality of produce are sufficient in themselves to induce customers inside.

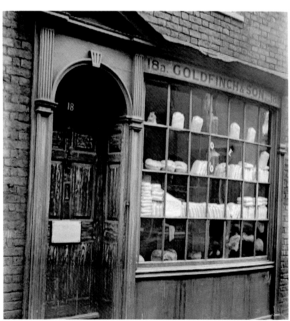

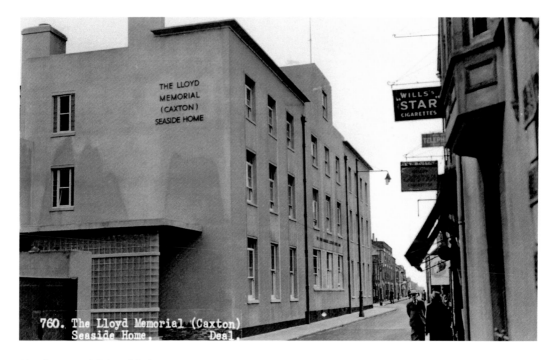

760. The Lloyd Memorial (Caxton) Seaside Home, Deal.

Lloyd Memorial Seaside Home

At the bottom of Alfred Square there is a large building called the Lloyd Memorial (Caxton) Seaside Home. It started life as the Alfred House Academy in the eighteenth century. Later it was renamed Deal College. When the school relocated to Thanet in 1911, it became a convalescent home for the printing profession and allied trades. A generous donation from the family of Edward Lloyd of Sittingbourne paper mills aided conversion. By 1969, however, the building was redeveloped into flats.

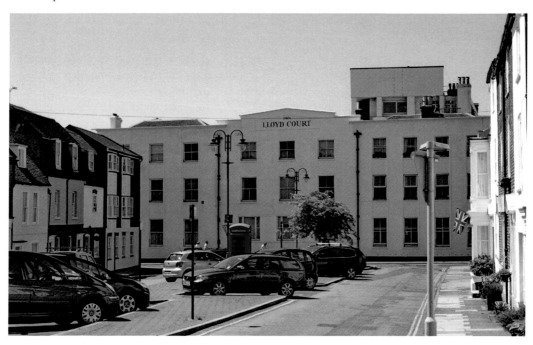

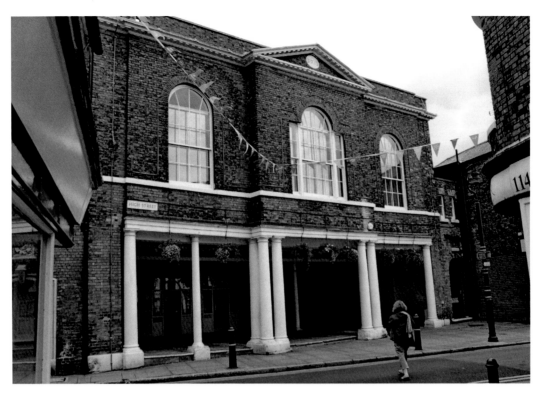

Deal Town Hall

Deal Town Hall was built in 1803 to replace an earlier one of 1719 in Lower or High Street. It was erected at the height of Deal's strategic importance during the Napoleonic wars and its design is typical of this regency period. Several organisations such as the police and fire brigade used its premises jointly including the town jail. Following local government organisational changes the chamber with its mayor's seat and aldermanic bench is no longer used. Masterfully designed and executed is a drinking fountain addition donated by Earl Granville who was Lord Warden of the Cinque Ports from 1865 to 1891.

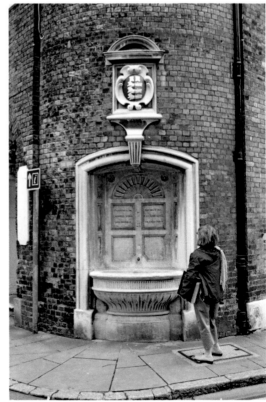

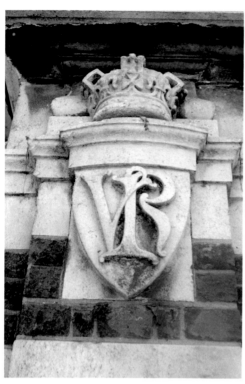

Architectural Features

Deal is exceptionally gifted with many listed buildings. Upon two historic structures these architectural features standout in every sense. The ship's figurehead looks out to sea attached to a Georgian residence while Queen Victoria's monogram is decorating the wall of the Marine Barracks.

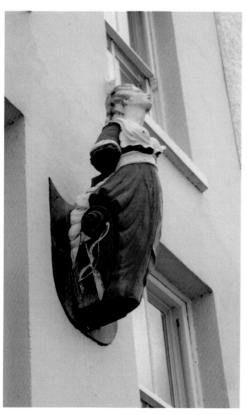

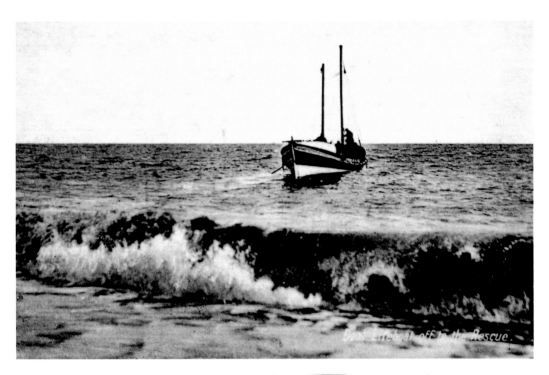

Deal Lifeboats I

Like the three Henrician castles, Deal also had three lifeboat stations. These have been amalgamated into one at Walmer. Old vessels had to rely on manpower and sails to rescue people in danger from shipwreck on the treacherous Goodwin Sands. Today, a powerful inflatable rib equipped with twin engines and a top speed of 36 knots is available, but exceptional seamanship (for which Deal boatmen are famous) is still required. Les Coe, pictured on the right next to his colleague Ian Packman, has devoted a remarkable fifty-seven years' service to saving lives at sea.

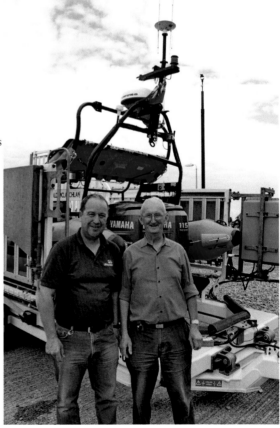

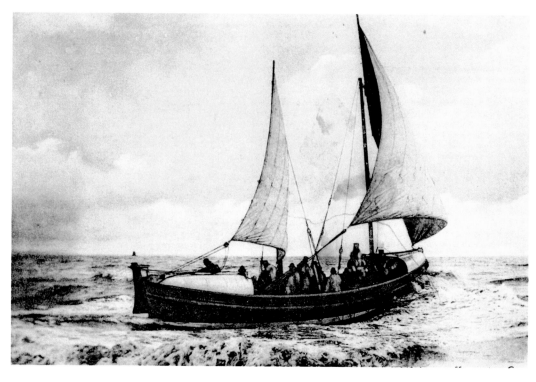

Deal Lifeboats II
The stone lifeboat station is pictured below. Over the years it has housed a variety of increasingly more efficient vessels. It also shelters a powerful caterpillar tractor which pushes the rib into the sea for launching.

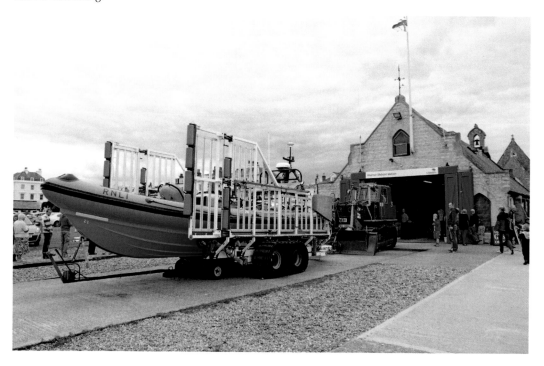

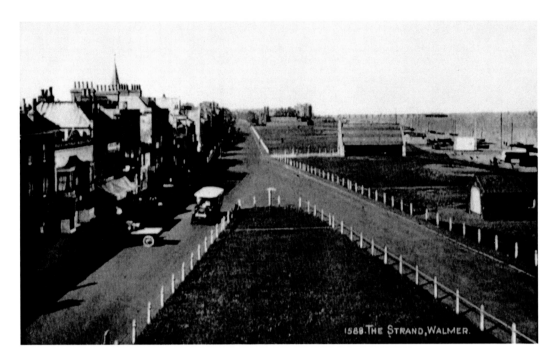

1588.THE STRAND,WALMER.

The Strand Walmer

The Strand Walmer runs continuously on from Deal beach and the early photograph above illustrates why these two towns eventually amalgamated for administrative purposes. Below, looking through masts of the Downs sailing club members' moored boats, a view southward gives a glimpse of the magnificent residential properties overlooking the Channel here.

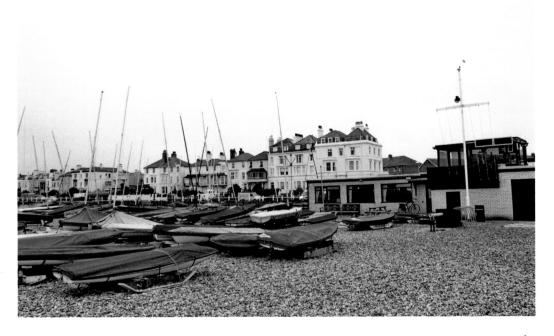

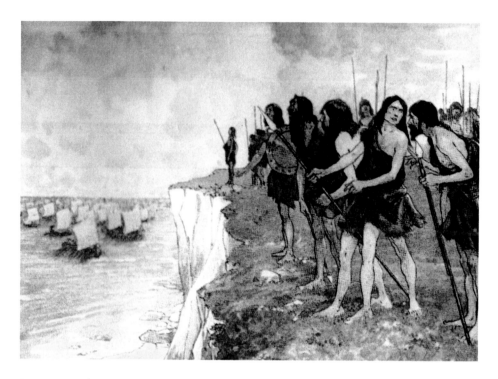

Roman Invasion

The Romans made several unsuccessful attempts to invade Britain. They did, however, eventually gain a first foothold on the shingle beach between Deal and Walmer. A concrete plaque marks this historic spot where Julius Caesar found his troops would not be pushed back by steep chalk cliffs and defending natives. The Romanisation of Britain not only changed the course of our destiny, but undoubtedly had profound long term ramifications for world civilisation.

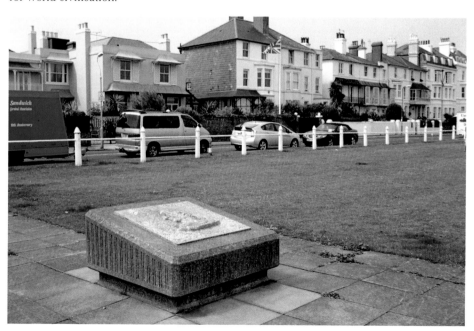

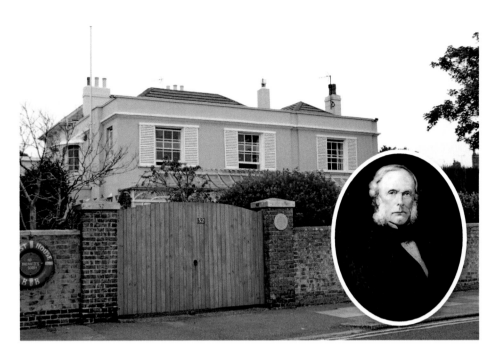

Joseph Lister

Joseph Lister, the pioneer of antiseptic surgery, died at his retirement home in Walmer at the age of eighty-four. He had had a very distinguished career following his discovery, while working at Glasgow Infirmary, that carbolic acid or phenol (as it is now known) used to sterilise medical instruments and clean wounds led to a dramatic fall in post-operative infection. Surgical operations became safer for patients and his expertise was even used to save Edward VII from appendicitis. The bacteria *listeria* and the mouthwash Listerine are named after him.

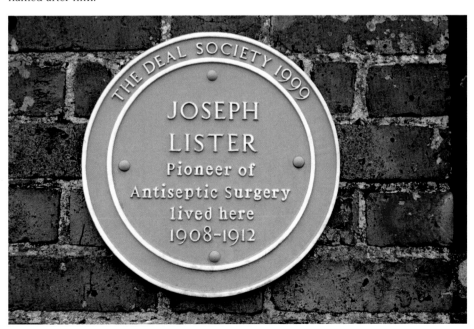

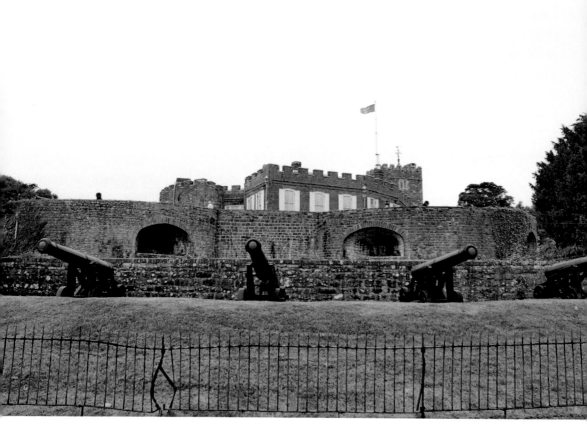

Wellington

The Iron Duke, conqueror of Waterloo and retired prime minister, died at Walmer Castle where he was in residence as Lord Warden of the Cinque Ports. Many of his personal artefacts remain at the castle, which is open to the public, including his eponymous boots and the chair in which he expired. Local legend has it that the old war horse would wander around the locality in his dotage with gold sovereigns in his pocket with which he would reward veterans of Waterloo that he might encounter.

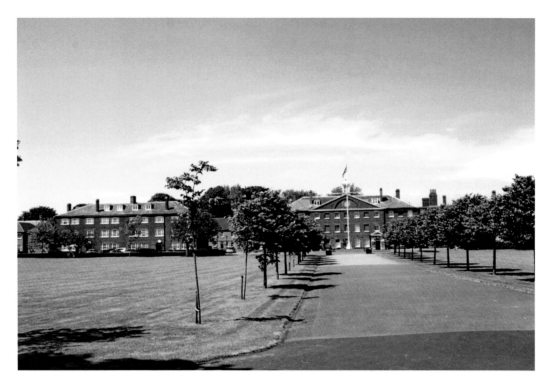

Royal Marines Barracks

The Royal Marines left Walmer and Deal in March 1996. They left behind noble buildings which were built during Napoleonic times. The School of Music's erstwhile home at Deal is pictured below with its elegant clock tower and cupola. Above the old substantial Walmer barracks are viewed from their entrance gates.

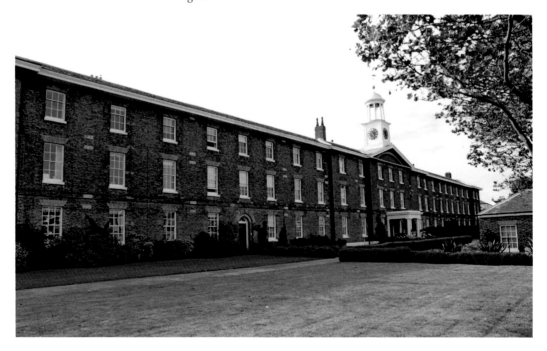

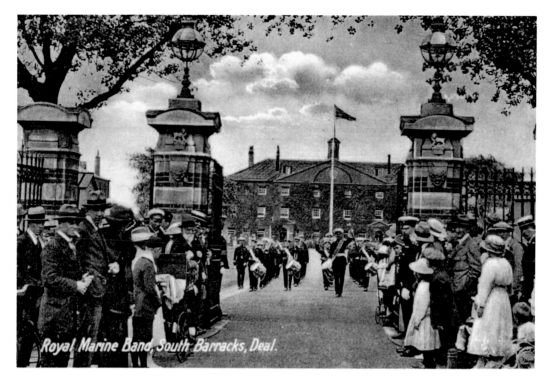

Royal Marine Band, South Barracks, Deal.

The Royal Marines I

The Royal Marine depot was established at Deal in 1861. The School of Music took young recruits at sixteen and trained them to be bandsmen and medical attendants. The old and new images on this page show previous and current musicians in firstly formal and then more relaxed mode.

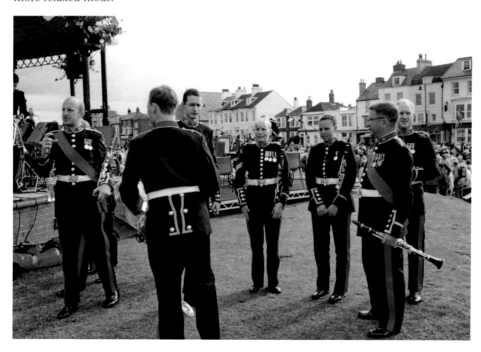

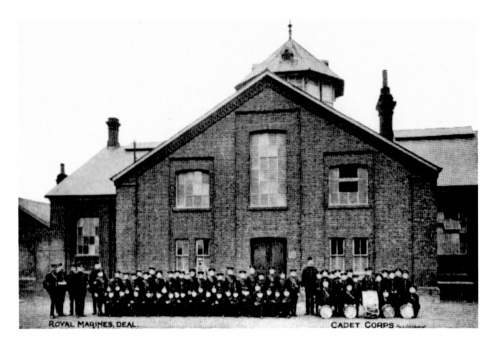

ROYAL MARINES, DEAL. CADET CORPS

The Royal Marines II

Universally admired and respected for the perfection of their musical performances the Marines' skills are only acquired through long training and inspired leadership. The image above shows young recruits lined up for a formal portrait in front of their barracks while the picture taken below is of bandsmen during an interval of their memorial concert at Walmer on 15 July 2012.

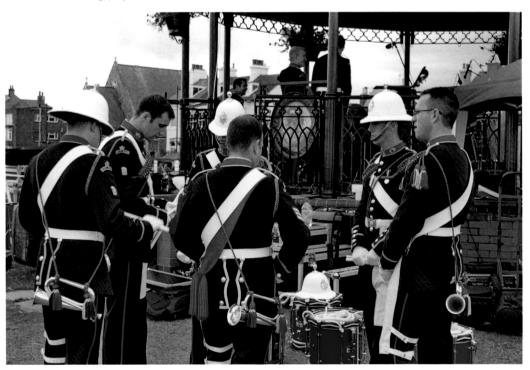

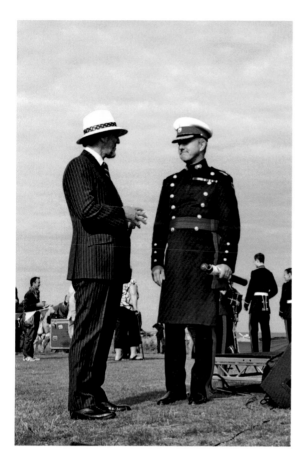

The Royal Marines III
In 1989 an IRA bomb explosion
rocked the town of Deal. This
infamous act of cowardly terrorism
killed eleven Marines in their quarters.
To commemorate their lives each year
the Royal Marine band performs a
concert at the memorial bandstand
supported by a huge audience of
around 10,000 people. The snapshot
to the right is of Major John Perkins
(Retired) and of Lieutenant Colonel
N. J. Grace and the one below captures
the Commandant General Royal
Marines Major General Edward Davis
CBE praising and congratulating his
musicians on their efforts on the
afternoon of 15 July 2012.

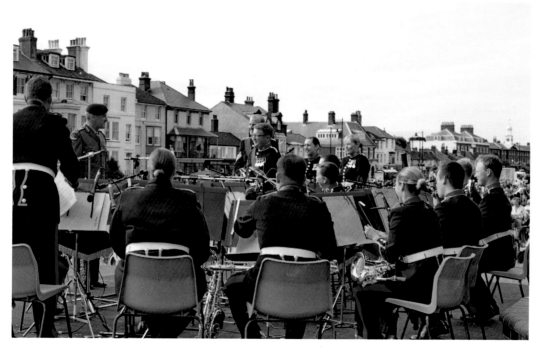

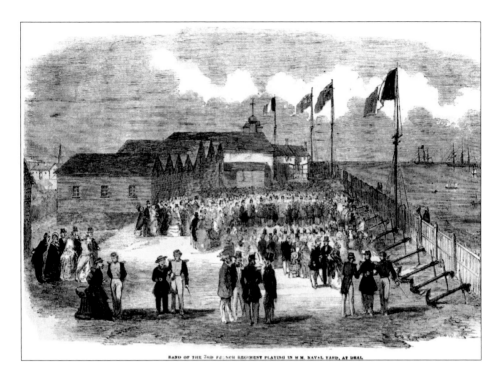

BAND OF THE 3RD FRENCH REGIMENT PLAYING IN H.M. NAVAL YARD, AT DEAL

The Royal Marines IV

The Victorian print above shows that military music at Deal has a long tradition. Here a visiting army band from France is playing to entertain a crowd at the old naval yard. Below, Major A. J. Smallwood is silhouetted against the sky while conducting an arrangement of songs by young ladies of the service.

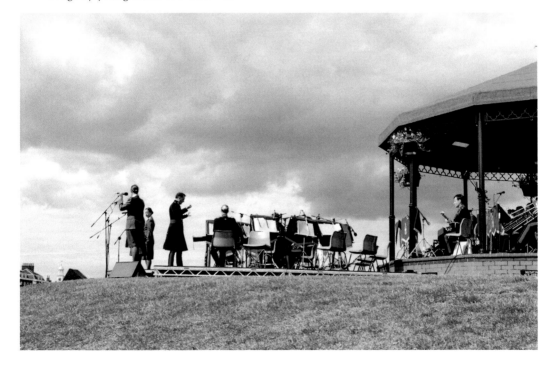

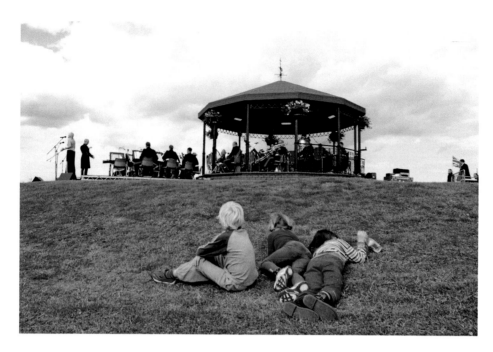

The Royal Marines V

No apologies for the extensive coverage of the Royal Marines memorial summer concert is made as the Corps have their spiritual base in Deal and have contributed so much to the life of the town. As they say, despite all atrocities and the passage of time 'the band plays on'. Infants gaze at the present orchestra accompanying soprano Margaret Threadgold to her stirring renditions of patriotic songs and other favourites from musicals. Below, a similar, but more sedate Edwardian scenario is depicted.

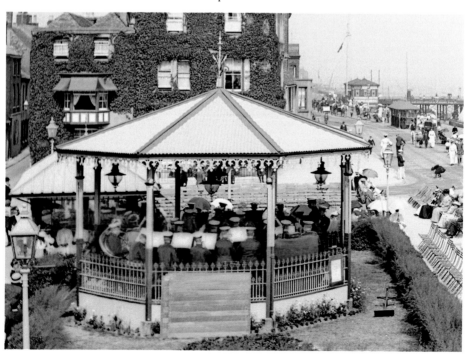

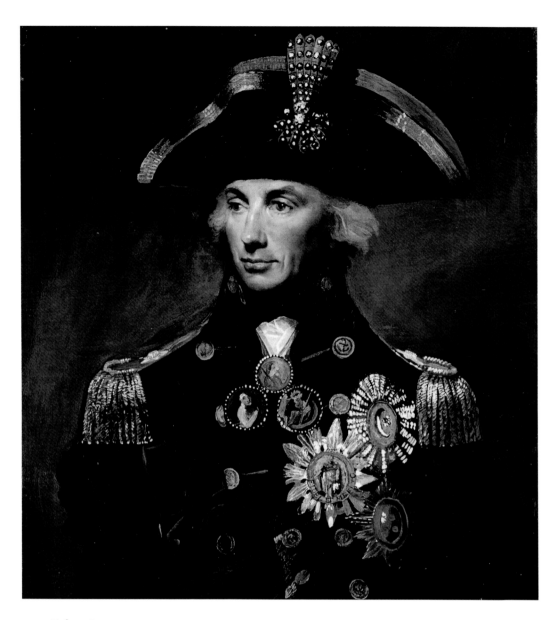

Nelson I

Nelson spent much time in Deal as the Downs was a major anchorage for the British fleet during war with France. He often visited his sick seamen in the nearby military hospital and is rumoured to have lodged at the Royal Hotel with Lady Hamilton. Certainly he used its jetty while being ferried to and from his warships. Sadly, his last visit to Deal was to last three days when bad weather delayed his corpse here while being brought back from his final great battle – Trafalgar.

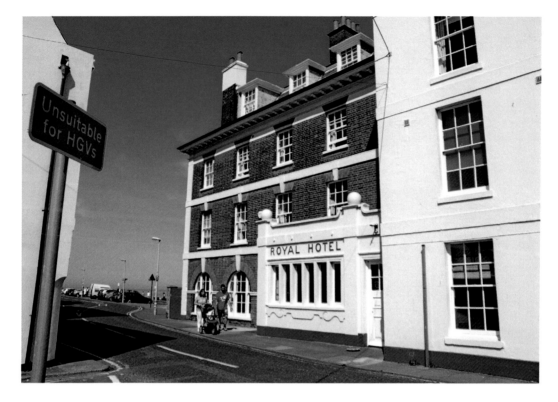

Nelson II

Other dignitaries apart from Nelson used the Royal Hotel, or as it was originally called the Three Kings after it was built in 1720. Princess Adelaide of Saxe-Meiningen slept here after her arrival in England in 1818 and caused the change of name. The Duke of York, who was commander-in-chief during the conflict with France, made strategic plans on the balcony with his aides. Later the Foreign Secretary's emissary Lord Lauderdale was a guest on his way to peace talks in Paris.

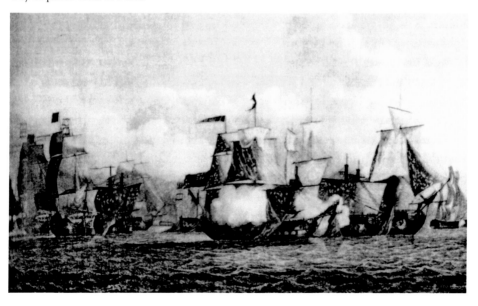

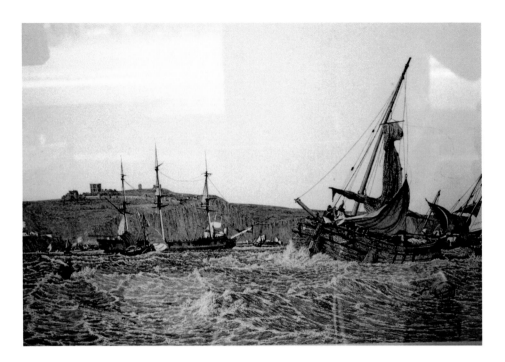

Deal's Naval Heritage

Upwards of four hundred ships sometimes anchored offshore in the Downs and their presence was a tremendous economic stimulus for Deal. Market gardeners and farmers supplied food and milk while boatmen ferried fresh water to vessels. Not only fighting ships stopped here. The vast East India Company fleet needed to be re-supplied along with England's armada of merchantmen who were busy expanding trade links and spreading British influence around the world. The print above provides an insight into this offshore community while the ship's relic below illustrates the craftsmanship employed in the construction of these ocean-going wooden boats.

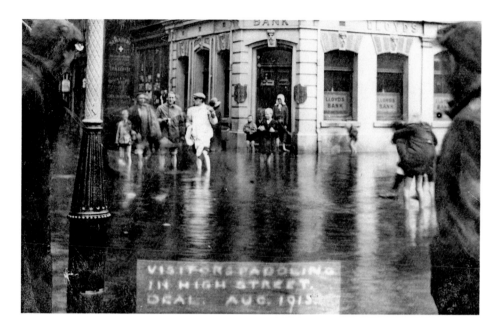

VISITORS PADDLING IN HIGH STREET. DEAL. AUG. 1915.

War and Disaster

Deal has over the years occasionally suffered flooding. The picture above was taken in 1915, with visitors paddling in the High Street. Another incident occurred in 1953 with wide spread floods over south-east England. The Second World War also brought suffering to the town. Along with Dover, Deal was within range of German long range guns twenty-five miles away in France. The tank parked in the street below was probably awaiting transportation to mainland Europe during the First World War.

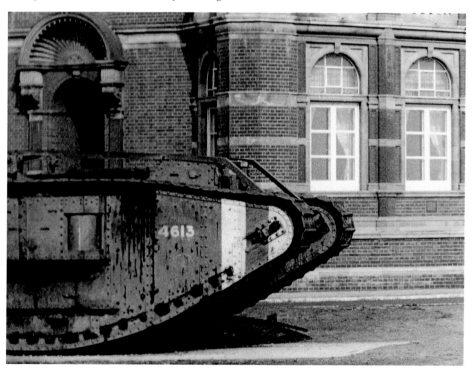

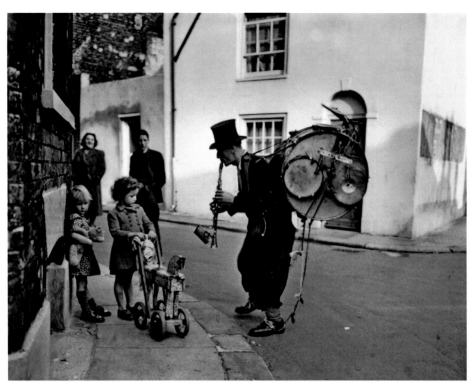

The One Man Band

This beautifully composed photograph launched the career of Deal gentleman Harold Chapman. He eventually became known as 'The Street Photographer', but his oeuvre occurred when *Reveille for the Weekend* published this work in 1952. The opportunity for an interesting subject to photograph occurred when Harold investigated strange noises coming from the corner of Farrier Street and Middle Street. Once there he encountered Arthur Griffiths, a medically retired miner bravely pursuing his unusual alternative career choice.

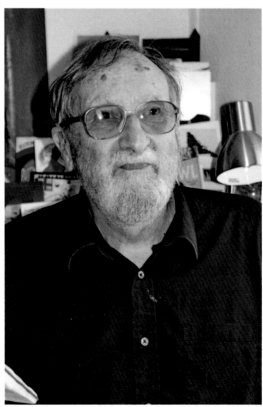

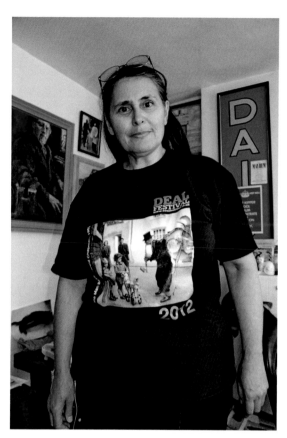

Deal Festival
Harold Chapman's brilliant image of sixty years ago was adopted as a motif for Deal Festival T-shirts as modelled by his wife Claire. This couple's artistic flair even extends to the design of their amusing house name plate, lovingly crafted below.

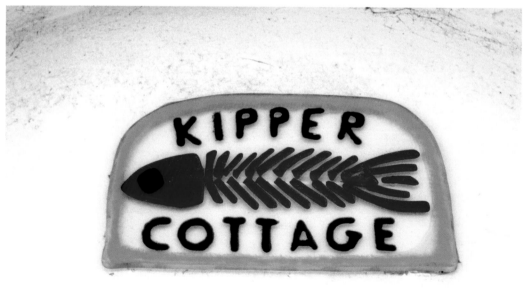

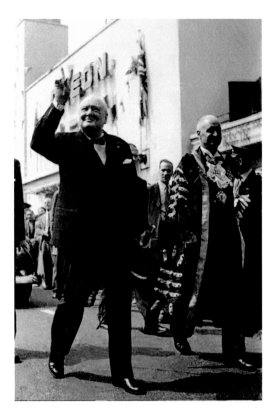

Churchill Receives the Freedom of Deal I
It is due to the generosity and goodwill of
Harold Chapman that these pictures he
took of Sir Winston Churchill receiving the
Freedom of Deal are shown. He rescued
them from a garage where they had been
stored for about thirty years. They were in
such poor condition that he had to spend
a day on each negative to restore them
enough to be printable.

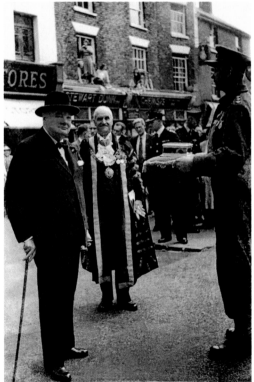

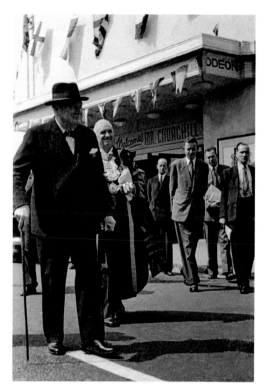

Churchill Receives the Freedom of Deal II
Taken in 1951 these photographs show an
ebullient statesman about to serve another
four years as Prime Minister. He sports his
usual bow tie and hat. Defiantly he gives
his signature gesture which symbolised his
irrepressibility and moral boosting attitude
during some of Britain's darkest days.

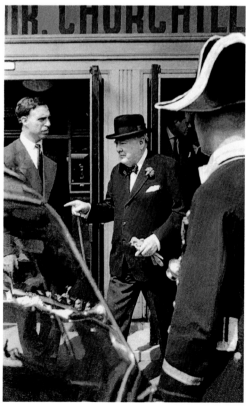

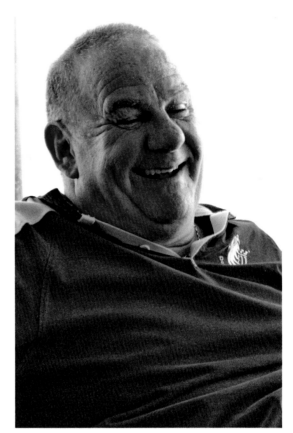

Deal and Betteshanger Rugby Club |
Club Director of Finance, Chris Tough,
has a smile of contentment as he
knows that everything at Deal and
Betteshanger Rugby Club is as it should
be. In July 2012 workmen were making
improvements and the smart clubhouse
at Canada Road, Walmer, smelt of
new paint. Deal Rugby Club started as
Walmer Wanderers in 1958 and soon
changed its name. In 2004 Betteshanger
Rugby Club amalgamated following the
closure of Kent's last colliery in 1989.

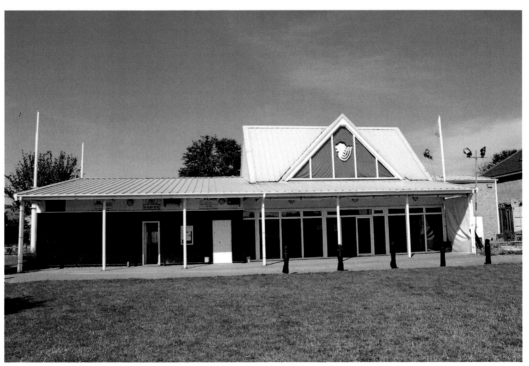

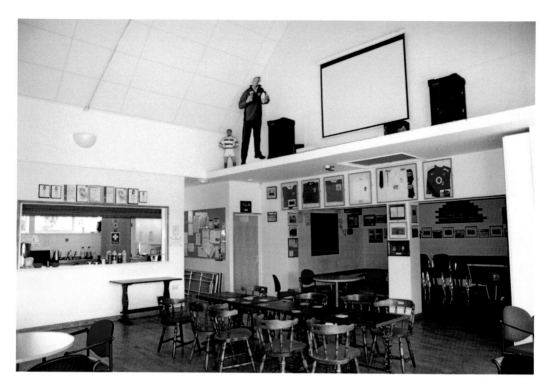

Deal and Betteshanger Rugby Club II
The clubhouse's equally well designed and pleasant interior is shown above juxtaposed to a team photograph donated by the Royal Marines. The club has long associations with the Royal School of Music and was devastated when the eleven victims of the IRA bombing, who all played at the club, were murdered.

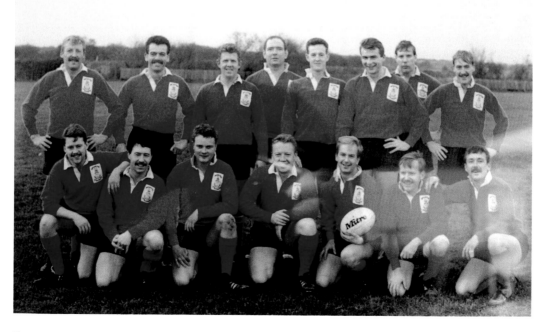

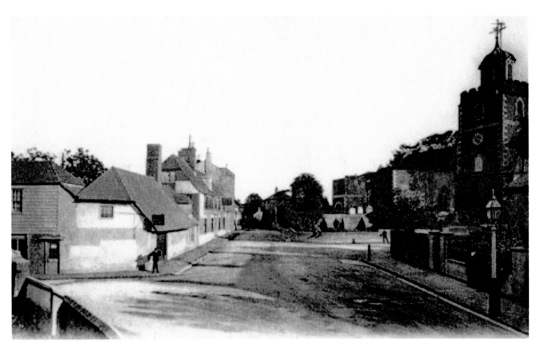

Upper Deal I
St Leonard's church sits amid Upper Deal, the oldest settled part of the town. It was established soon after the Norman Conquest. The original tower collapsed after five hundred years and its replacement dates from 1680. In the vestry local worthies congregated to form their earliest government organisation. They obtained a grant of charter of incorporation for the town.

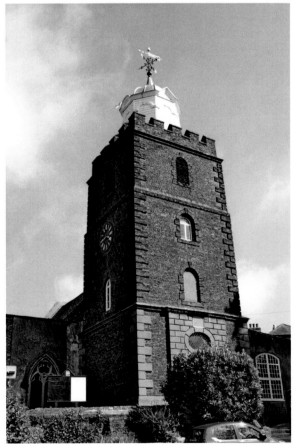

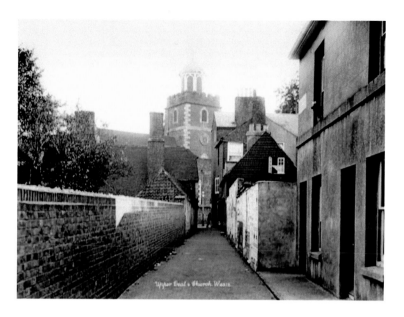

Upper Deal II

The picture above shows an old shot of St Leonard's from another aspect. Opposite this fine parish church is arguably Deal's oldest hostelry. The Admiral Keppel was at least two hundred years old when its name was changed. Local legend records that Admiral Keppel, who had won fame for the capture of Havana, drank here when his luck was down after being accused of letting the French fleet escape at Ushant. A court martial subsequently acquitted the Admiral of all blame and he went on to distinguish himself as First Lord of the Admiralty.

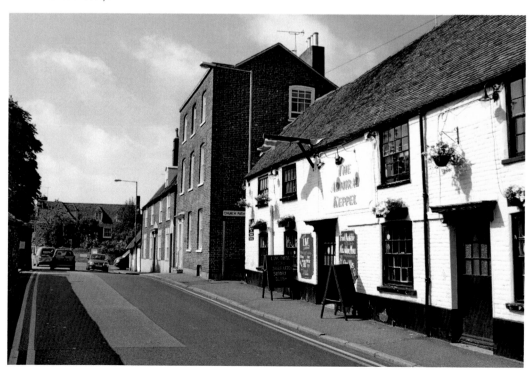

Betteshanger Colliery

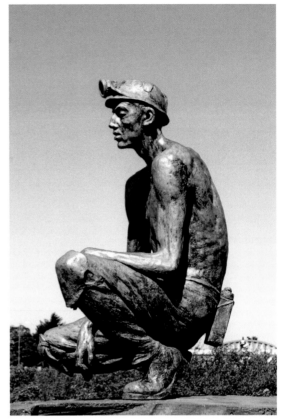

Coal was discovered in east Kent by accident while shafts were dug attempting to tunnel under the Channel. These early efforts were fruitless, but a rich coal seam was exploited at a number of deep collieries including Betteshanger near Deal, which operated from 1927 to 1989. Many unemployed miners from other regions in Wales and the north moved to find work at Betteshanger. A memorial statue to Kent miners who lost their lives in industrial accidents is placed near the roundabout at Fowlmead Country Park.

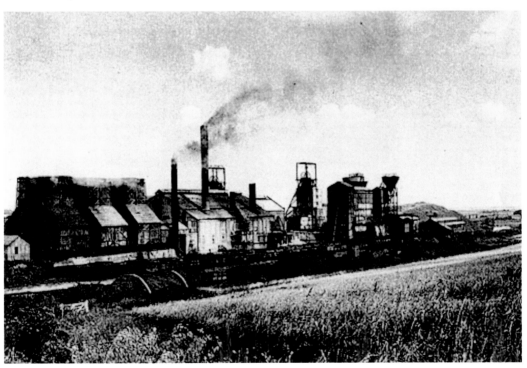

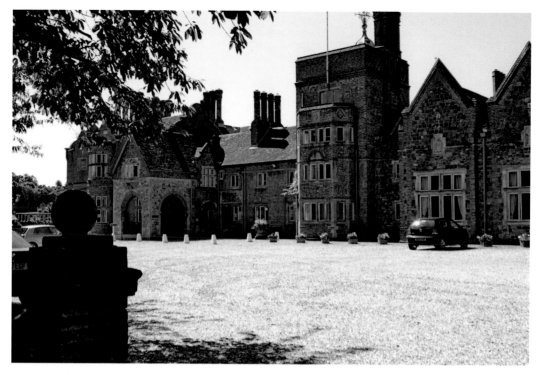

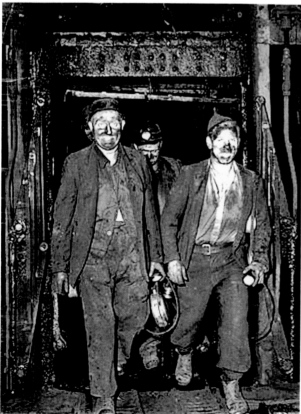

Betteshanger House
Rather incongruously the grime of mining deep below Betteshanger belied the beauty of the countryside above. Set among this fine rolling paradise is Betteshanger House, which is now a school.

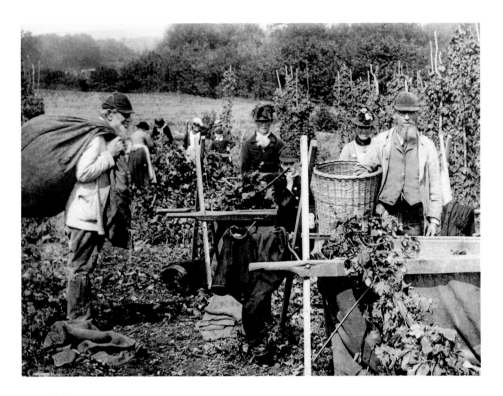

Hop Picking

These sepia images of Victorian hop pickers evoke a lost era when whole families went to harvest hops in the fields around Deal. This intensive style of farming has largely disappeared in this area, but in any case the essential flowers are now mechanically stripped from the bines.

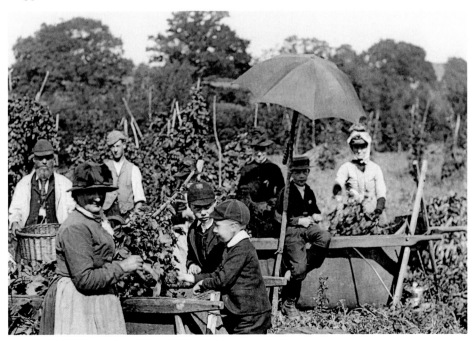

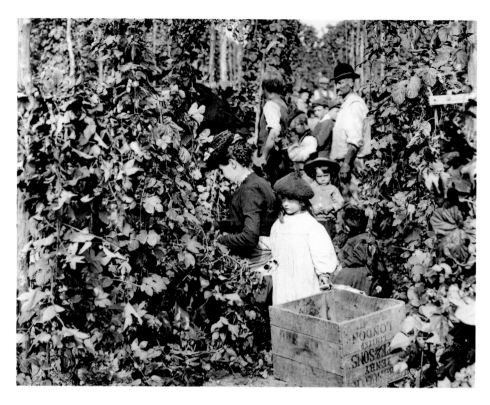

Farming Then and Now

Another intimate and nostalgic image of communal work in the hop gardens is shown here. Little greater contrast to this old way of farming could be made than by comparison to a massive crop sprayer at work on large cornfields today.

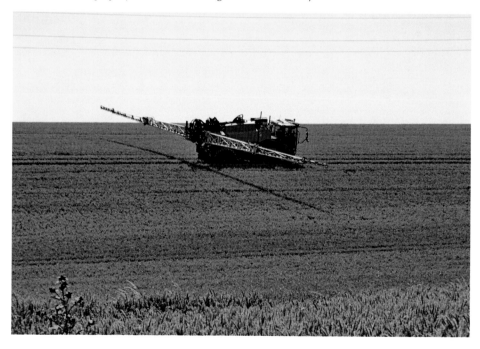

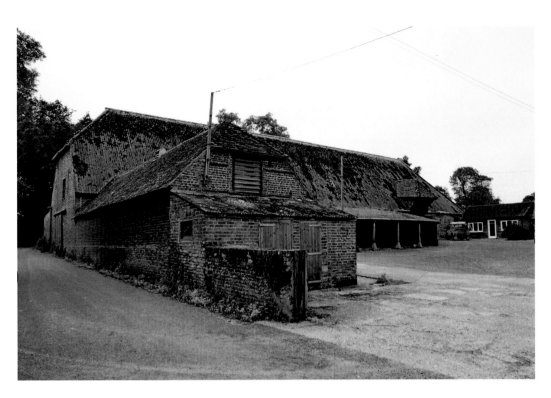

Extensive Arable Farming

Some very progressive arable farmers operate on the fertile fields surrounding Deal. Judging by the enormity of the old barn in the picture above this has long been an area of large scale agricultural enterprises. Certainly the expense of state of the art implements below can only be justified on massive holdings.

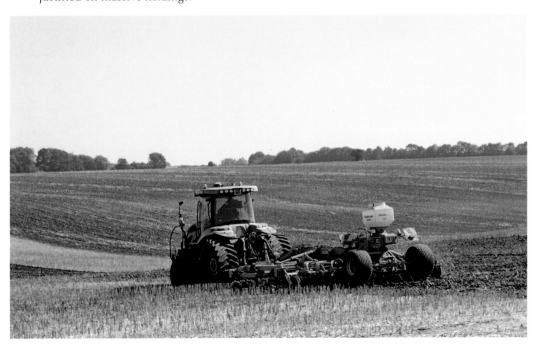

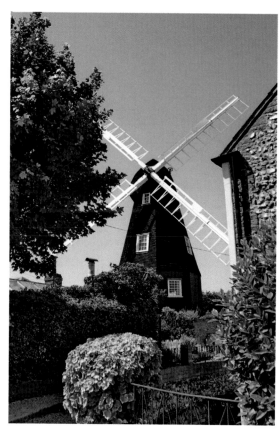

Windmills

Due to the topography of Deal – placed on the east coast of Kent – it has had a high density of windmills. The picturesque one above has been converted into a dwelling, but it is well preserved and an interesting landmark cutting the skyline on the main road into the town.

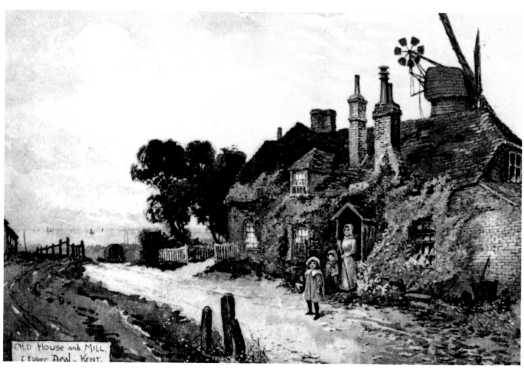

OLD HOUSE and MILL
[]ower Deal – Kent.

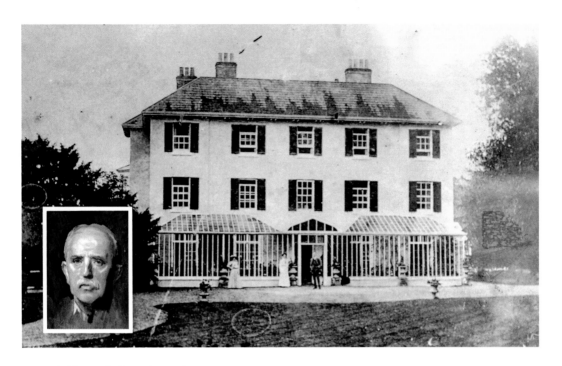

Field Marshal Lord French

Field Marshal Lord French, hero of the Boer War and First World War commander, was brought up at his family home in Ripple, a delightful village nestling in the folds of hills behind Deal. Inset over the old picture of this house is a revealing portrait by John Singer Sargent. A complex and sometimes controversial character, the old warrior died at Deal Castle and was buried in Ripple churchyard.

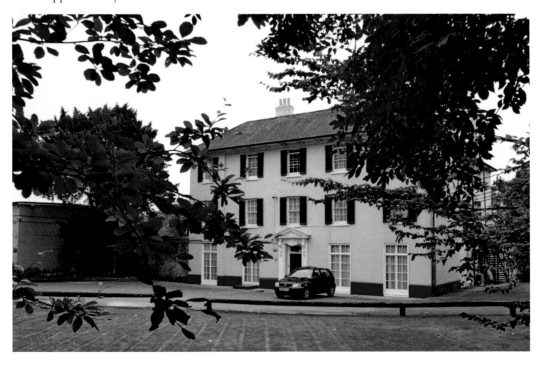

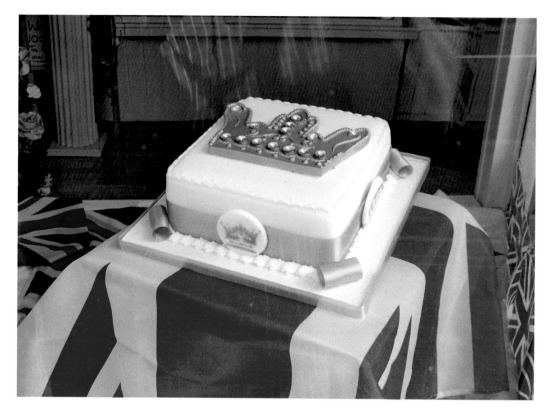

Jubilee and Olympic Celebrations 2012

This volume concludes with two celebratory pictures of a notable year for both Deal and the country generally. Firstly a patriotic cake marking the Queen's Diamond Jubilee was snapped in a shop window in Upper Deal. Secondly Katherine Betts, a long standing lifeguard officer, is seen holding the Olympic Torch which she had the honour of carrying.

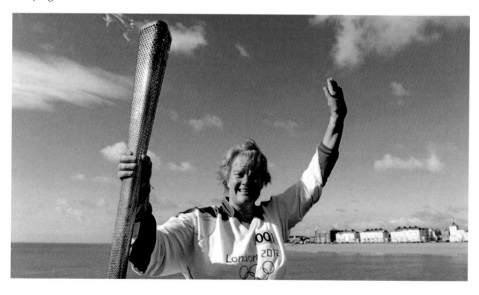

Acknowledgements

First and foremost, a great debt of gratitude is owed to Harold and Claire Chapman whose instinctive generosity made available a number of fascinating old pictures of Deal together with the selfless offer of free copyright use of some of their own exceptional photographic work. Thereafter, thanks are due to Chris Rapley for the trust given while hiring postcards from his extensive stock. Much appreciation for neighbour and friend Trac Fordyce's computer wizardry is also expressed. Lastly I wish to thank Jo Elvy, Marianne de Longer and my beloved partner Jocelyn for all their help, companionship and encouragement. Should I have failed, through any error of commission or omission to include anyone who has contributed in any way whatsoever, I apologise and would be willing to include their details in subsequent reprints.

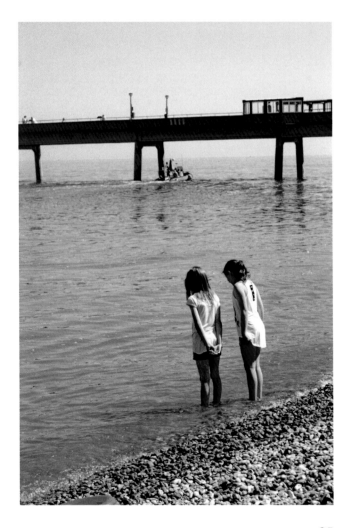

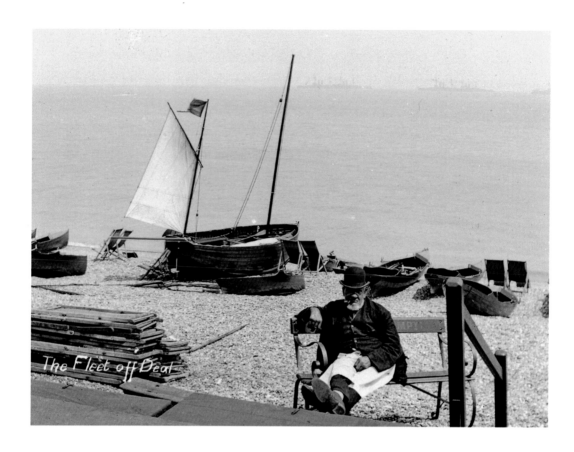

The Fleet off Deal

The barbarous hated name of Deal shou'd die,
Or be a term of infamy;
And till that's done, the town will stand
A just reproach to all the land.

Daniel Defoe